Photographing
Big Bend
National Park

Number Forty-seven • W. L. Moody Jr. Natural History Series

A&M travel guides

Photographing

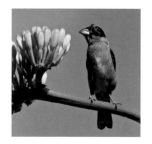

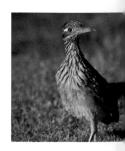

Texas A&M University Press
College Station

Big Bend National Park

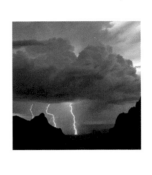

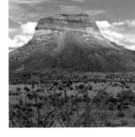

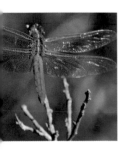

A Friendly Guide 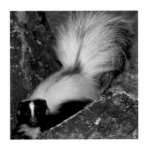 to Great Images

Kathy Adams Clark

This paper meets the requirements of
ANSI/NISO Z39.48-1992 (Permanence of Paper).
Binding materials have been chosen for durability.

Library of Congress Cataloging-in-Publication Data

Clark, Kathy Adams, 1955–
 Photographing Big Bend National Park : a friendly guide to
great images / Kathy Adams Clark. — 1st ed.
 p. cm. — (W. L. Moody Jr. natural history series ; no. 47)
 Includes index.
 ISBN-13: 978-1-60344-817-8 (flex : alk. paper)
 ISBN-10: 1-60344-817-9 (flex : alk. paper)
 ISBN-13: 978-1-60344-823-9 (e-book)
 ISBN-10: 1-60344-823-3 (e-book)
 1. Big Bend National Park (Tex.)—Guidebooks. 2. Outdoor
photography—Texas—Big Bend National Park—Amateurs'
manuals. I. Title. II. Series: W.L. Moody, Jr., natural history
series ; no. 47.
 F392.B53C59 2013
 976.4'932—dc23
 2012019927

To my husband,
Gary,
who introduced me to
Big Bend National Park
so many years ago

Contents

Preface

MY FIRST VISIT to Big Bend National Park was frustrating. Every scene captured my eye and excited my senses. "Stop the car. I need to take a picture," I'd yell, but my traveling companions, husband Gary Clark and friend Mike Austin, would keep driving.

Typical of most residents of Texas, I'd never visited Big Bend. Though born in Texas, my parents took me on vacations to Bryce Canyon, Yellowstone, the Grand Canyon, and other spectacular parks in the western United States. They later told me that they never thought of visiting Big Bend National Park even though it was only four hours from our home in El Paso.

Many times as a young adult I thought of visiting the park. Some other destination always seemed more attractive. It wasn't until I married my husband, Gary, a long-time visitor to the park, that a visit to Big Bend became a reality. From that first visit, I've been hooked and can think of nowhere else I'd rather be.

Big Bend National Park covers eight-hundred-thousand acres of land in far west Texas. The park preserves a broad swath of the Chihuahua Desert that includes the last mountain peaks of the Rocky Mountains.

The combination of wildlife, desert, mountains, and wide-open spaces give photographers plenty of subjects. The park also gives us views of the Rio Grande, ancient pictographs left behind by Native Americans, remnants of twentieth-century ranch life, and exposed geology. Add to that early morning and late evening sunlight, summer thunderstorms, and clear dark skies, and the photographic opportunities become limitless.

This book is designed to give you photography tips that I've gathered over many visits to Big Bend National Park. The tips and techniques are for anyone using a camera no matter how simple or complex the camera. Tips

are also designed to benefit the novice photographer as well as the more experienced photographer.

I hope you enjoy your visits to the park as much as I have over the years. My aim is to help you come away with spectacular photographs that you will treasure for a lifetime.

This book would not be possible without my husband, Gary Clark. He introduced me to Big Bend National Park and has encouraged our visits over twenty-plus years. He stood by patiently waiting as I captured many of

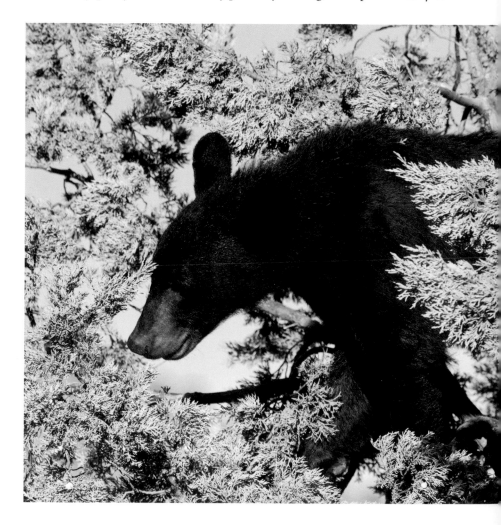

the images you see here. Thanks to Patti Edens and Janice Braud for reading and rereading the text of this book to ensure it made sense and was technically accurate. Thanks to both ladies for traveling to Big Bend National Park and encouraging me to capture new and different images. Special thanks to Patti for helping me with the more technically challenging night images. Janice and I moved into the digital photography world together, so thanks also for helping in those early years. Thanks to Bill Dambrova of Canon for being there when I had a camera or equipment question. Thanks to Kevin Adams for sharing your knowledge about night photography and for talking about landscape photography over the years. My sincere thanks to the National Park Service and everyone at Big Bend National Park for maintaining such a lovely place for public use. Special thanks to Shannon Davies and the staff at Texas A&M University Press for shepherding this project through. ■

Black bear feeding on juniper berries in the Basin.

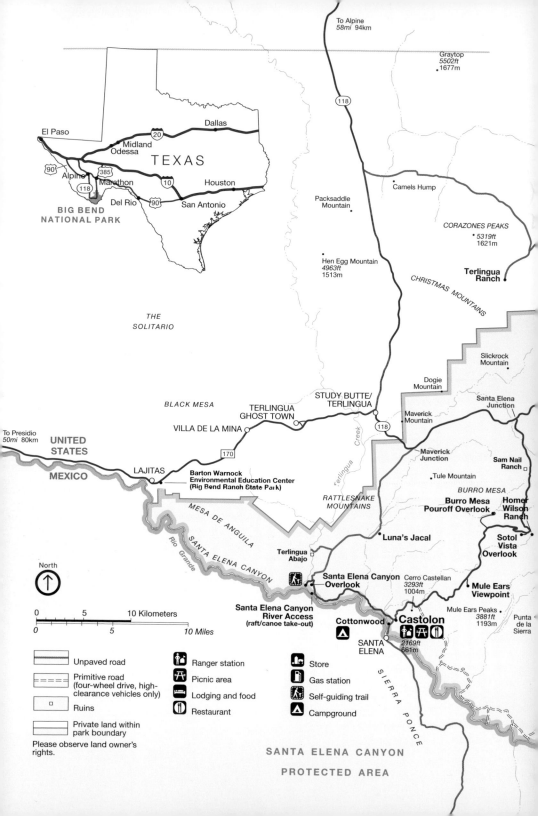

To Alpine
58mi 94km

Graytop
5502ft
1677m

118

Camels Hump

CORAZONES PEAKS
5319ft
1621m

Terlingua
Ranch

CHRISTMAS MOUNTAINS

Packsaddle
Mountain

Hen Egg Mountain
4963ft
1513m

THE
SOLITARIO

Slickrock
Mountain

Dogie
Mountain

Santa Elena
Junction

BLACK MESA

TERLINGUA
GHOST TOWN

STUDY BUTTE/
TERLINGUA

Maverick
Mountain

VILLA DE LA MINA

170

118

Maverick
Junction

To Presidio
50mi 80km

UNITED
STATES

LAJITAS

MEXICO

Barton Warnock
Environmental Education Center
(Big Bend Ranch State Park)

RATTLESNAKE
MOUNTAINS

Tule Mountain

Sam Nail
Ranch

BURRO MESA

Burro Mesa
Pouroff Overlook

Homer
Wilson
Ranch

MESA DE ANGUILA

Rio Grande

SANTA ELENA CANYON

Terlingua
Abajo

Luna's Jacal

Sotol
Vista
Overlook

North

Santa Elena Canyon
Overlook

Cerro Castellan
3293ft
1004m

Mule Ears
Viewpoint

Santa Elena Canyon
River Access
(raft/canoe take-out)

Cottonwood

Castolon

Mule Ears Peaks
3881ft
1193m

Punta
de la
Sierra

0 5 10 Kilometers

0 5 10 Miles

SANTA
ELENA

2169ft
661m

SIERRA PONCE

Unpaved road

Primitive road
(four-wheel drive, high-
clearance vehicles only)

Ruins

Private land within
park boundary

Please observe land owner's
rights.

Ranger station

Picnic area

Lodging and food

Restaurant

Store

Gas station

Self-guiding trail

Campground

SANTA ELENA CANYON

PROTECTED AREA

Texas inset map

To Alpine

El Paso

Dallas

Midland
Odessa

TEXAS

20

Alpine

Marathon

Houston

10

385

118

Del Rio

90

San Antonio

BIG BEND
NATIONAL PARK

90

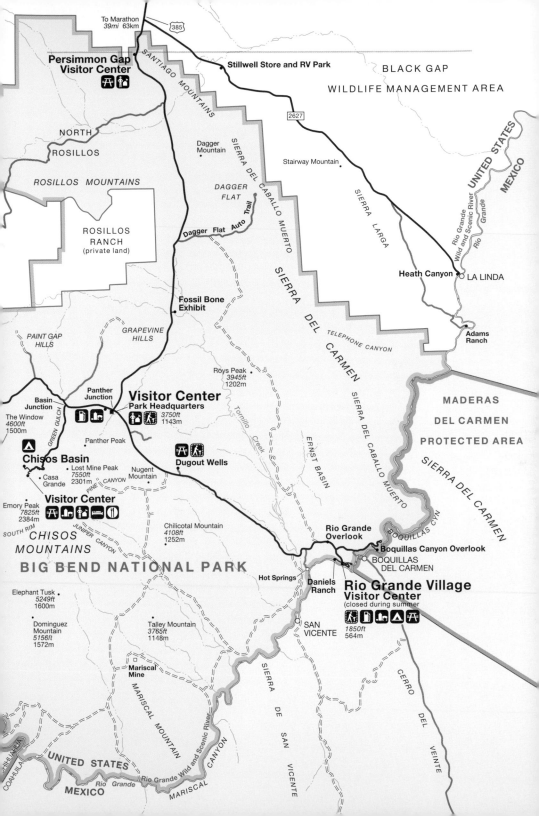

Summer lightning storms in Big Bend National Park offer photographers a challenging opportunity to capture stunning images.

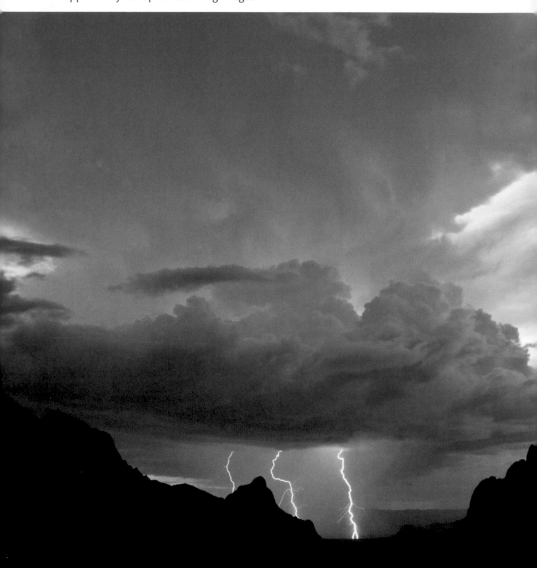

Photography for Everyone

THE OBJECTIVE OF PHOTOGRAPHY is to duplicate what we see with our eye. That's elementary. A really good photograph, though, is sprinkled with a little magic from the camera. A great photograph can make something look better than we see with our eye. Good photographs begin with the basics.

When we point our camera at a scene, we see the objects in the scene like mountains, buildings, or people. The camera sees light objects, dark objects, things in shadows, and highlights. Our task in taking a picture is to learn to "see" like the camera. We then need to guide the camera to record the lights and darks, shadows and highlights, so we get a photograph of the objects in the scene.

A well-exposed image is a photograph that captures the lights, darks, shadows, and highlights. Exposure is a balance between light and dark, producing a photo that looks like what you see with your eye. A properly exposed photo begins with the light meter.

The Purpose of the Light Meter

The light meter is a small device inside your digital single lens reflex (dSLR) camera. Light from your subject enters the camera through the lens, travels through the camera body across the light meter, and arrives through the viewfinder at your eye.

The light meter in your dSLR camera is called a "through the lens" light meter. That means light is measured through the lens opening. Photography involves training your eye to see light as the light meter sees light.

The light meter is one way your camera communicates with you. Pay attention to the light meter, and you'll get a well-exposed image. Accomplished photographers rely on their light meter for every picture.

Ward Mountain with the light meter balanced using the center-weighted light meter.

Ward Mountain at the same time using the spot meter. The light meter scale is in the middle showing a balanced light meter and good exposure.

Ward Mountain under the same conditions with the evaluative light meter.

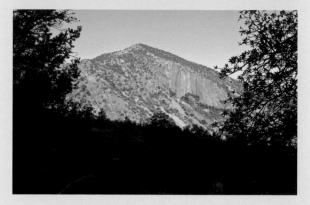

Modern cameras have three to four types of light meters. Each light meter "sees" the light in a slightly different way and gives a slightly different end result.

The Different Kinds of Light Meters

The simplest light meter is called a center-weighted light meter. It was the first in-camera light meter developed by engineers in the middle of the twentieth century. The center-weighted light meter reads light in the entire scene and averages all the light. It puts an emphasis on the area in the center of the frame because it assumes your main subject is in the center of the frame.

The downside to the center-weighted light meter is that all the light in the scene is averaged. Darks and lights blend together to give mixed results. The center-weighted light meter yields good results if there are no really light or really dark areas in the scene.

Spot or partial light meters came about later and revolutionized photography. The spot meter or partial light meter (Nikon calls it spot and Canon calls it partial) only reads light in one small area of the frame. All the rest of the light in the frame is ignored.

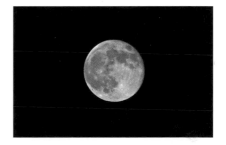

The center-weighted light meter averages light throughout the frame. The moon is over-exposed since it is against a dark sky. The light meter is trying to bring out some of the detail in the sky.

The spot or partial light meter does a better job in this photograph of the full moon. The spot or partial light meter is reading light only from the center of the frame and ignoring the light in the dark sky. As a result, we get a properly exposed moon.

Spot or partial metering allows us to photograph a light subject against a dark background. The dark background does not enter into the exposure. We can photograph a hawk against a bright blue sky using spot meter and the blue sky won't enter into the exposure. This means the hawk will be properly exposed and the sky may be dark or light depending on the light hitting the hawk.

The spot or partial light meter reads light in the middle of the frame on most cameras. The area can be as big as 10 percent of the frame or as narrow as 1 percent of the frame. In some cameras, the spot meter follows the focus point so the area being metered can be anywhere around the middle of the viewfinder.

This is a fabulous feature because the subject we want to be perfectly exposed can be off-center against a darker or lighter background. As long as we balance our light meter off the subject using spot or partial meter, the subject will be well exposed.

Spot or partial meter is used when there is a really dark area or a really light area in the frame. We should take our meter reading, or get our exposure, off the subject we want to be properly exposed.

A new light meter came on the market along with autofocus cameras in the mid-1990s. This light meter is called evaluative, matrix, honeycomb, patterned, or multi-segmented depending on the camera manufacturer. We'll call it evaluative/matrix in this book.

The evaluative/matrix light meter reads light throughout the frame in five or more segments. The light in each segment is averaged and then the light in all segments is processed again to get a proper exposure.

The evaluative/matrix light meter will yield a good exposure most of the time. The only time it doesn't work, as in the center-weighted meter, is when there is a really light area in the frame or a really dark area.

Camera manufacturers are constantly tinkering with technology to read the light and give a properly exposed photograph. Each new generation of cameras brings better light meters to the market.

Which Light Meter Do You Use?

With three to four light meters to choose from, there's a lot of confusion. I use evaluative/matrix 99 percent of the time. When I have a subject

against a really dark background or a really light background, then I switch to the spot or partial meter.

A word of caution is in order, though. Every camera manufacturer puts different technology into their light meters. A lot of engineering goes into cutting-edge light meters. Test your camera and see how each meter records a scene. Learn the engineering that went into your camera. The information above is the theory, but the results vary from brand to brand and model to model.

There's a way to verify if you have the right exposure, and that's called the histogram. That comes later, though.

All photographs start with the light meter. We look at the scene we want to photograph and decide which light meter we should use. The evaluative/matrix meter is great for scenes most of the time. Spot/partial would be used when we want to properly expose one particular area in a scene.

How to Use the Light Meter

The light meter shows up when your camera is in the manual mode.

Action Rotate the dial on the top of your camera to M. If you don't have a dial, push the mode button and rotate your main dial to M.

Usual answers to questions:
- No, not the M on your lens. That turns off autofocus and we don't want to do that.
- Yes, manual mode. You are now in charge of the camera and will learn how to operate this fabulous machine you spent hundreds of dollars on.

Action Push the shutter button halfway down and look through the viewfinder.

The light meter scale shows up through the viewfinder.

The light meter communicates with you through that scale on the bottom right corner of the viewfinder. In some cameras, the scale is along the right side of the viewfinder. In other cameras, the light meter talks to you through a number with a plus or minus next to it.

In most cases, for a proper exposure, the light meter indicator should be centered in the middle of the scale. If your light meter is a number with a plus or minus next to it, the number should be set to 0. (There are exceptions, but we'll deal with them later.)

The light meter scale indicator goes in the middle, or the light meter number to 0, by rotating the shutter speed dial and f/stop dial. There are several combinations of shutter speed and f/stop that will put the light meter scale indicator in the middle, or the number to 0, and all of these combinations will produce a well-exposed photograph.

The light meter is very sensitive.

Balancing the Light Meter with the Shutter Speed and f/stop

The light meter scale indicator goes to the middle, or to 0, by changing the shutter speed and/or f/stop. When we get the scale indicator in the middle, we then look at the shutter speed and f/stop with our eye and then decide with our brain if those two numbers will make our photo look the way we want it to look.

The combination of shutter speed and f/stop yields a photographic outcome. The meter scale will balance with endless combinations. Our brain has to make the right combination to give us the photo we want.

Shutter speed is indicated with numbers like 1000 or 1/1000, 500, 250, 125, 60, 30, 15, 8, 4, 2, 1", 2", to bulb. The 1" means one full second. The 1000 or 1/1000 means a thousandth of a second.

Rotate the dial to get the fastest shutter speed. Rotate your dial to get the slowest shutter speed.

Usual answers to questions:

- 8000 is 1/8000th of a second but chances are you'll never use it.
- 4000 is 1/4000th of a second and is rarely used.
- 2000 is 1/2000th of a second. It is used in sports and nature photography.
- 2" is two full seconds (one second, two seconds) and there are a lot of neat things to be photographed with two full seconds if your camera is on a tripod. More on that later.
- Bulb means that your shutter will stay open as long as you hold the shutter button down. That yields some great photography. More later.

Shutter speed stops movement. The shutter is located in front of the sensor. It opens and closes to let light hit the sensor. A slow shutter speed blurs action. A fast shutter speed freezes action.

- 1/8th of a second shutter speed blurs water. The water cascading down a waterfall becomes a dreamy mass of white. The water tumbling over rocks becomes smooth and silky.
- 1/15th of a second shutter speed stops gentle movement. A wildflower gently blowing in a light breeze will stop.
- 1/60th of a second shutter speed stops a living creature standing still. A smile will be stopped. A bird perched on a branch or a squirrel standing still on a rock will be stopped.
- 1/250th of a second shutter speed will stop walking or trotting. A deer walking across the parking lot will be crisp in the photograph.
- 1/500th of a second shutter speed stops quick movement. A jackrabbit will be frozen in mid-hop. A running horse will be stopped.
- 1/1000th of a second shutter speed will stop a bird in flight. A hawk exploding into flight from a branch will be frozen. The wings of a mockingbird will be stopped.

F/stop controls how much we see and don't see in a photograph. F/stop is a number assigned to the opening in the lens. The opening in the lens is

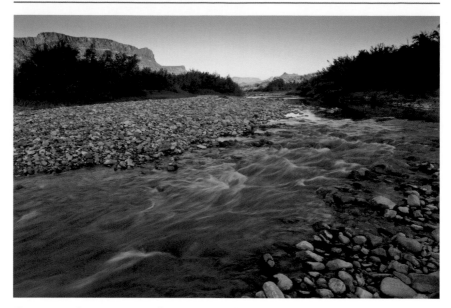

Shutter speed set to 1/8 sec allows water to blur.

Shutter speed set to 1/15 sec stops the gentle movement of a wildflower.

Shutter speed set to 1/60 sec stops the basic movement of a rock squirrel.

Introduction

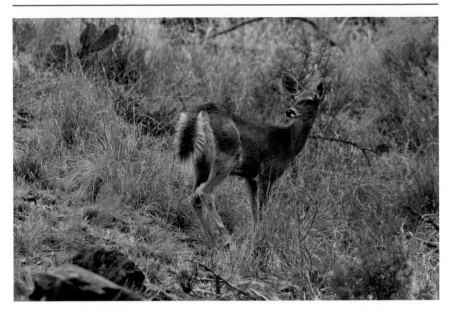

Shutter speed of 1/250 sec stops the alert movement of a white-tailed deer.

Shutter speed of 1/500 sec or 1/1000 sec stops the rapid flight of a mockingbird in mid-air.

f/8 allows a moderate depth-of-field to be shown in the photograph.

f/5.6 gives a soft background because of the narrow depth-of-field.

f/2.8 produces minimal depth-of-field so only the tiny bloom is in focus.

- Cameras with a thumb dial and a finger dial: one dial controls shutter and one controls f/stop.
- Cameras with a finger dial and a large round dial on the back: the finger dial controls shutter and the large round dial controls f/stop. (Be sure the large dial is unlocked.)
- Cameras with only one dial: push and hold the +/– button while rotating the dial. This will change your f/stop.
- F/stop is controlled by your lens. Some lenses will go to f/32 and some only go to f/22. On the opposite end of the scale, some will go to f/4.5 and some will only go to f/5.
- Zoom your lens to see if you can get a bigger or smaller f/stop. Variable f/stop zoom lenses are common. They are light and inexpensive but the f/stop changes with the zoom.

called the aperture. The aperture controls how much depth-of-field, or area in focus, we have in a photograph.

- f/32 or 22 is a tiny aperture opening. Everything from near to far will be in focus. Landscape photographers use f/32 or f/22 to get maximum depth-of-field from the foreground through to the background. (For maximum depth-of-field and maximum sharpness, professional landscape photographers use f/16 or f/11. One day I'll explain why. For now, don't think about it.)
- f/8 is a moderate aperture opening with most things in focus. There's an old saying in photography that goes "f/8 and be there." That means put the camera on f/8 and shoot. Most stuff will be in focus.
- f/5.6 is a large aperture opening with only a few things in focus. Use an f/5.6 to photograph a wildflower against a background that is soft and out-of-focus.
- f/2.8 is a really large aperture opening with very little depth-of-field or area in focus. This is an f/stop rarely used in everyday photography. It has a place in specialty photography, though, and with 50mm lenses.

The bigger the f/stop number the smaller the aperture opening. The smaller the aperture opening, the greater the depth-of-field in the final photograph. Confused? Most people are. An easy way to remember this is:

- At f/32: thirty-two things are in focus.
- At f/2: two things are in focus.
- The bigger the f/stop number the more things that are in focus.
- The smaller the f/stop number the fewer things that are in focus.

F/stop controls how much of the finished photograph is in sharp focus versus how much is soft or even blurry. People tend to study objects in a photograph that are in focus and scan or skip over objects that are out-of-focus. Their eye is drawn to a hummingbird and stays on the hummingbird if the background is blurry. If they can see the background in sharp focus, then their eye wanders to the background. They lose interest in the hummingbird.

A good landscape photograph is usually done at f/22 or f/32. Everything will be in focus. The viewer's eyes can wander through the photo and study all the things that are in the scene.

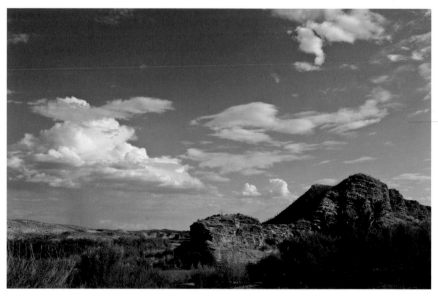

f/22 produces a large depth-of-field so the viewer can see everything in the photograph.

ISO: How it fits into balancing the light meter

ISO is a number that controls how sensitive the sensor is to light. A low ISO of 100 or 200 tells us the sensor is recording light at the engineered minimum. That minimum yields the finest quality photograph and best color for that camera.

A higher ISO, on the other hand, records light faster. Grain, or noise as we call it in the digital world, is more pronounced and color is sacrificed. The trade-off is we can get a faster shutter speed under lower light.

A setting called "internal noise reduction" can rectify high ISO noise in the camera. It can also be smoothed out in the computer with special software.

A high ISO of 400 or 800 or even 3200 yields very little noise in expensive cameras that cost many thousands of dollars. On cameras costing less,

Action *Balancing your light meter*

- Set your f/stop to 5.6. There's nothing magic about 5.6. All lenses have a 5.6 setting so it's easy to use for this action.
- Rotate your shutter dial to put the light meter scale indicator in the middle. Hint: if you're inside a house the shutter speed will be around 1/8th or 1/15th second. That's 8 or 15 on some cameras. If you're outside in bright light the shutter speed could be 1/125th or 1/250th of a second.
- Point your camera at something else. Rebalance the light meter with the shutter speed dial.
- Repeat, repeat, and repeat.

Usual answers to questions:
- Scale won't move? Rotate the shutter speed dial the other direction. You're rotating the wrong way and it's hit its max.
- Can't get the shutter to go below 60? Turn off Auto ISO. You'll learn about that in the next section.
- The scale keeps jumping around? Yes, it's sensitive. As the tones in your scene change, it changes.
- Can't get faster than 1/20th of a second shutter speed inside? Correct. Not enough light. Can't photograph a running horse inside the house.

a high ISO can make photographs unacceptable. On older digital cameras, high ISO is totally unacceptable.

Some photographers like pronounced grain in the photograph. This is called the "grunge" look. The look is achieved with a high ISO or added later with software in post-processing.

Take a few test photos at high ISO and then blow them up to 100 percent on your computer. If the results are acceptable to you, then you know raising your ISO is an option.

Personally, I keep my ISO as low as possible so I don't have to use special software later on.

Pulling It All Together: Light Meter, Shutter Speed, f/stop, and ISO

When we put a camera on the "program," "auto," or "green box" mode, the camera balances its light meter with a factory-engineered shutter speed and f/stop. Most of the time, the camera does a pretty good job. Small point-and-shoot cameras work well in these modes.

Digital SLR cameras work well like this too, but good photography comes from learning how to use the light meter, shutter speed, f/stop, and ISO. Accomplished photographers look at the shutter speed and f/stop combination that balances their light meter and decide if those two numbers will yield the photograph they want. A good photograph has the right shutter speed to stop the movement and the right f/stop to show the appropriate depth-of-field.

The manual mode is an excellent way to learn shutter speed and f/stop. It takes more time to shoot in the manual mode but it's a good place to learn. Stay in the manual mode until balancing your light meter with the f/stop and shutter speed becomes routine. You'll thank me for this later!

You may wonder if you should start balancing the light meter with shutter speed or f/stop. A photograph of a flower in a vase can begin with either. Lead with the shutter speed if the flower is moving. Lead with the f/stop if you want a soft background.

A photograph of a smiling adult begins with 1/60th of a second shutter speed. We have to stop their movement, so we lead with the shutter speed. Shutter speed stops movement. F/stop controls how much of a scene is in focus or out of focus.

Did you get more depth-of-field than you need? For example, at 1/60th of a second shutter speed with f/16 for a sitting person, more area will be in focus than is needed for a good photograph. Move the f/stop to f/8 and adjust the shutter speed accordingly until the light meter scale indicator moves to the middle.

Is f/8 too much depth-of-field for the sitting person? Move the f/stop to 5.6 and readjust the light meter with the shutter speed, moving to a faster shutter speed. Anything faster than 1/60th of a second shutter speed is lagniappe so it won't hurt. The shallower depth-of-field will make the photo of a sitting person look better because the background will be softer and less distracting.

A photograph of a landscape begins with setting the aperture to f/22 or f/32. That small opening in the aperture means the light meter will balance with a slow shutter speed. A slow shutter speed means handholding the camera will result in vibrations and a blurred photograph. To get a faster shutter speed, increase the ISO. Alternatively, put the camera on a tripod to keep it steady.

Action *Photograph a flower in a vase*

1. Put a flower in a vase outside on a stool or table.
2. Set your f/stop at 5.6.
3. Get on eye level with the flower
4. Look through your viewfinder and fill the frame with the flower and vase.
 a. Zoom in and out to make this work. If that doesn't work, back up or walk closer.
5. Push the shutter button halfway down to activate the camera.
6. Rotate the shutter speed dial to balance the light meter scale.
7. Push the shutter button halfway down one more time to focus.
8. Push the shutter button all the way down to take the photo.

Usual answers to questions:
- Camera won't let me take the photo! The camera is set to one shot or single shot. Move the auto focus to "continuous" in Nikon and Sony or "Al-Servo" in Canon.
- The camera wants to focus on the background! Deactivate all the focus points and just use one. Nikon calls this single point.

1. Place the person or pet in front of you. Keep your back to the sun to put light on the subject.
2. Set your shutter speed to 1/60 or 60.
3. Get on eye-level with the subject.
4. Look through the viewfinder and fill the frame with your subject.
5. Push the shutter button halfway down to activate the camera.
6. Rotate the f/stop dial to balance the light meter scale.
7. Push the shutter button halfway down one more time to focus. Try not to let up this time.
8. Push the shutter button all the way down to take the photo.

Usual answers to questions:
- Raise your ISO if you can't get the light meter to balance at a low f/stop like 3.5 or 4.0. Remember to lower the ISO when you are finished as you only use this feature when needed.
- The picture is blurry! Hold the camera steady. Grip the camera. If your subject moved, take another photo and see if that works.

Water blurs at 1/8th of a second. That's a slow shutter speed so a tripod is necessary. No tripod? Put the camera on a stool or other solid object.

The shutter speed and f/stop combination we use should make sense for the photograph you want. A photograph of a static subject against a soft background would begin with an f/5.6. Then the shutter speed dial is rotated to get the light meter scale in the middle. Raise the ISO if the shutter speed is too slow or put the camera on a tripod.

Checking Your Work: Playback and Histogram

One of the beauties of digital photography is the ability to look at the photo immediately after it's taken. No more wondering if the shot worked or didn't work. The LCD panel displays the photo and we make a decision to keep it or send it to the trash.

There's a great way to verify that the exposure was correct, as well. We can do that through the histogram.

The histogram is a graph of the 256 tones that are possible in a

1. Find a landscape. Go to your backyard, in front of your house, up on your roof, or look out the window. Keep your back to the sun to put light on the subject.
2. Set your f/stop to f/16.
3. Look through the viewfinder.
4. Compose the scene you'd like to photograph.
5. Push the shutter button halfway down to activate the camera.
6. Rotate the shutter speed dial to put the light meter scale indicator in the middle.
7. Push the shutter button halfway down one more time to focus. Try not to let up this time.
8. Push the shutter button all the way down to take the photo.

Usual answers to questions:
- A shutter speed in the 4, 8, 15, or 30 is going to yield a blurry photo because of camera shake. Take the picture anyway for this exercise. Alternatively, put the camera on a tripod or raise the ISO.
- The picture is blurry! Hold the camera steady. Grip the camera. Try not to move when you push the shutter button.

photograph if the photo were converted to black and white. The far left of the histogram represents solid black with no detail and the far right represents solid white with no detail. In between are all the tones in the photograph from black to white.

A good histogram covers the entire graph. There can be peaks and valleys throughout the histogram but it should cover the entire graph.

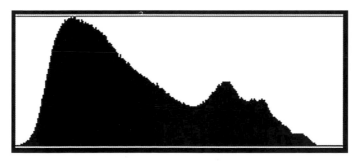

The histogram for a photograph shows up on the back of the camera under image playback. A good histogram covers the entire graph with no spike up the right side.

Action *Photograph running water*

1. Find some running water. Go to your backyard and turn on the garden hose, find a fountain in a park, or go to the kitchen sink. No tripod? Put your camera on a stool or other solid object.
2. Set shutter speed on 8 or 1/8.
3. Look through the viewfinder.
4. Compose your photograph.
5. Push the shutter button halfway down to activate the camera.
6. Rotate the f/stop dial to put the light meter scale indicator in the middle.
7. Push the shutter button halfway down one more time to focus. Try not to let up this time.
8. Push the shutter button all the way down to take the photo.

Usual answers to questions:
- A shutter speed of 1/8 of a second is going to yield a shaky photo if the camera is not stable. Raising the ISO won't help here because we want a slow shutter speed.
- Use the camera's timer to eliminate shake after you click the shutter.

A spike on the right, or white edge, of the histogram is a potential problem. A spike just before the solid white is okay but not a spike up the edge. A spike on the far right side of the histogram indicates that many solid white pixels exist in the photo. Those pixels contain no information or color detail.

Those solid white pixels are shown in the highlight indicator on the LCD panel. Anything blinking has no detail and will be pure white on the finished photo. That's not good. A white wildflower that blinks on the highlight indicator is over exposed. White clouds that blink on the highlight indicator are over exposed and have no details. (The highlight indicator appears on the same screen as the histogram in Canon cameras, but Nikon owners need to go into the display menu and turn on the highlight indicator and histogram. Then click "ok" to confirm.)

What happens if there are highlights blinking? Underexpose the image a bit by dialing the light meter toward the negative sign.

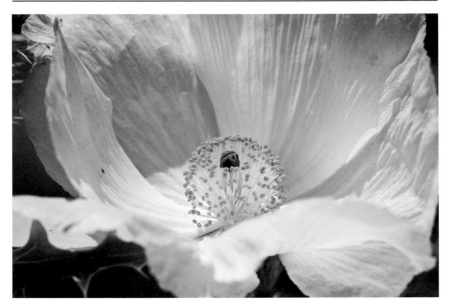

The histogram for this photograph of a white prickly poppy should stretch across the graph but not spike on the right side.

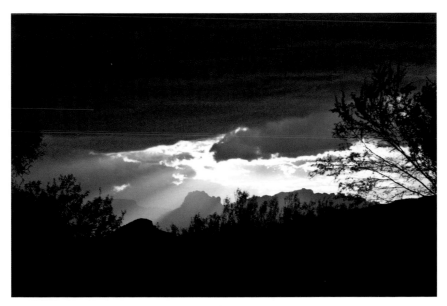

The area around the sun will blink on the highlight indicator. That's okay as long as the area is small and isolated.

What happens if the histogram doesn't stretch all the way to the white side? Overexpose the image a bit by dialing the light meter to the positive sign.

A word from experience. The sun in a sunset will always show up as a blink on the highlight indicator. Light bulbs in a room or in a scene might blink on the highlight indicator. Don't worry about these. But we don't want the clouds to be blinking on the highlight indicator. That means the clouds are white with no detail. That's not a good thing.

1 The Basin

THE BASIN IS RIGHT in the middle of Big Bend National Park. It's roughly two hours from Marathon to the north and one hour from Study Butte on the park's western boundary.

The Basin is appropriately named because it's a bowl-shaped geologic feature on the top of the Chisos Mountains. The Chisos are the result of ancient volcanic basalt, or underground magma, that pushed up through the softer surface. That surface eroded away over millions of years to expose russet colored rocky outcrops that ring the Basin.

The largest of these basalt giants is called Casa Grande. It looms about a thousand feet above the Chisos Mountains Lodge, campground, and visitor

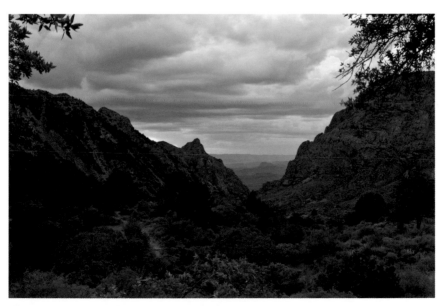

The Basin area in the Chisos Mountains looking west.

center. Smaller mountain ranges arch away from Casa Grande in both directions and meet to form the Window.

The Window is a notch in the mountains that forms a near-perfect V-formation. Luckily for photographers, the sun sets right down the middle of that notch in the summer. There's an old adage in photography that "while photographing the sunset, remember to turn around to check out the light behind you." That holds true in the Basin. The setting sun bathes Casa Grande in golden light and gives us two main subjects to photograph every evening.

Sunset through the Window

The sunset through the Window is the iconic photograph that most people associate with Big Bend National Park. Images of the Window have appeared thousands of times in magazines, books, and calendars.

Photographing the sunset is easy. Stand anywhere along the quarter-mile Window View Trail. The trailhead is next to the Basin Store off the main parking lot. The best spots are where the park service has placed several park benches.

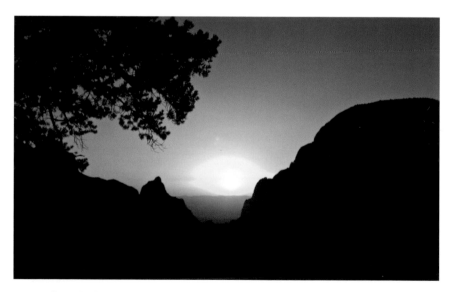

Sunset through the Window from the Window View Trail.

Place your camera on a tripod. Compose the photograph so that the lower tip of the notch in the Window is right above the lower edge of your photograph.

The notch in the Window is deep, so I recommend a wide-angle lens. An ultra-wide-angle lens in the 10mm or 16mm range will give a nice wide expanse of mountains across the bottom of the photograph as well as nice clouds or sky in the top of the photograph. A wide-angle lens in the 17mm to 24mm range will give a narrower view of the mountains and less sky.

A lens in the 28mm or 35mm range will have trouble getting the entire notch and sky in the photograph. Take your photo from the patio of the restaurant if this is the only lens you have. The restaurant is higher and farther back toward Casa Grande, and therefore gives a better view with these lenses. Note that many point-and-shoot cameras have a lens in the 28mm to 35mm range.

Simple: Point your camera at the scene and click the shutter.

Intermediate: The simple point and click yields mixed results. Sometimes the rich colors in the sky show up on the photo, but most of the time the

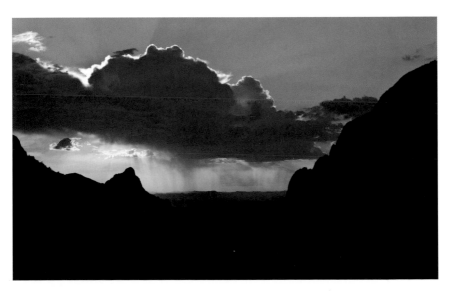

Sunset through the Window with the light meter set for the sky and under exposed by one stop.

sky lacks detail. Rich colors in the sky and a deep black silhouette of the foreground comes from getting a meter reading off the sky.

Put the camera in the manual mode. Leave the autofocus turned on but rotate the mode dial to M or press the mode dial and rotate the dial to M. The light meter is now visible in the bottom right corner of the viewfinder or along the right margin of the viewfinder. (For more information about using the light meter, read the section "How to Use the Light Meter" in the introduction.)

Point your camera up in the sky away from the bright area of the sun. Select an f/5.6 for the f/stop and rotate the shutter speed dial until the scale goes right in the middle. Continue rotating the shutter speed dial until the scale is negative one stop under exposed or −1 if your camera doesn't use a scale.

Bring the camera back down, compose the scene as instructed above, and securely lock the camera on the tripod. Remember the notch of the V in the Window should be near but not touching the bottom edge of the scene through the viewfinder.

The light meter will move to the right or left because the sun is in the scene. Don't readjust it by rotating the f/stop or shutter speed dial. We want the exposure to be set for the sky away from the sun.

Hold the shutter halfway down to let the camera autofocus on one of the mountain ranges. Click the shutter to capture the scene. You should get a photo of a beautifully colored sky with the mountains in deep, rich black silhouette.

Advanced: Balance the light meter with an aperture of f/22. Select the shutter speed that puts the light meter one stop under exposed. The f/22 will turn the sun into a star burst if the picture is taken when the sun peaks around the edge of a cloud or the mountain. Add the silhouette of an agave stalk as an added touch.

Season: The best time of year to photograph the sunset is May through August. That's when the sun goes down into the notch formed by the Window.

Casa Grande

Casa Grande towers over the entire Basin. It's huge, rugged, and made up of hundreds of different hues of rock. The changing light during the day illuminates the formation in different ways, so snap photos often.

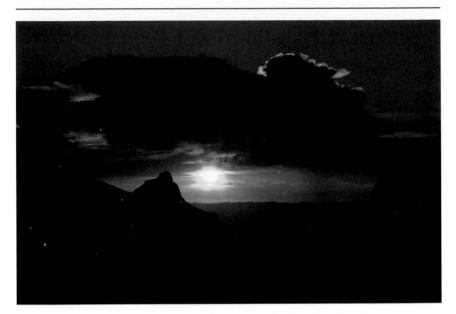

Sunset through the Window with the light meter set for the sky and under exposed by one stop.

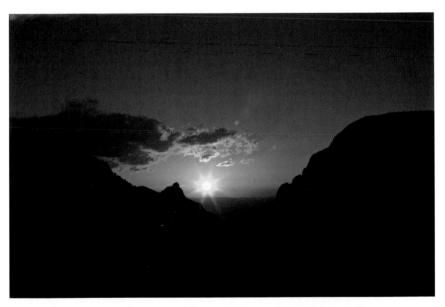

Sunset through the Window with the f/stop of 22 to get a star burst on the sun.

The main parking lot outside the Basin Store is a great vantage point. The view changes a bit from the parking lot behind the restaurant. The view is dramatic from the amphitheater near the Basin Campground.

The light is best from noon to past sunset since the sun comes up behind Casa Grande and to the left.

Simple: Take a picture of Casa Grande

Intermediate: Include the restaurant or motel in your photograph to show Casa Grande in context. Don't like to include the "hand of man" in your photos? Then put an interesting foreground in your photo. Find a yucca in the parking area to put in the foreground. Focus on the yucca and let Casa Grande loom large in the background.

Advanced: Scout your vantage point in advance and be in position a half hour before the official time that the sun goes down. A well-composed photo includes foreground that leads the eye to Casa Grande, then Casa Grande, and then some sky.

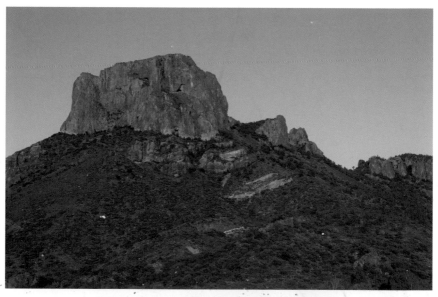

Casa Grande photographed from the parking lot outside the Basin Store.

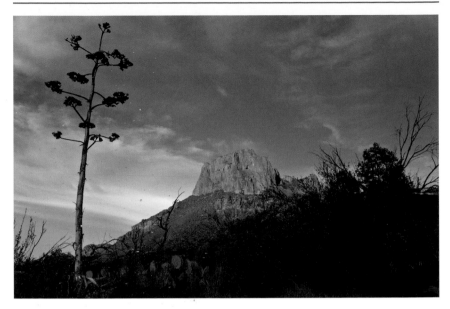

A yucca in the foreground creates a frame for a photograph of Casa Grande.

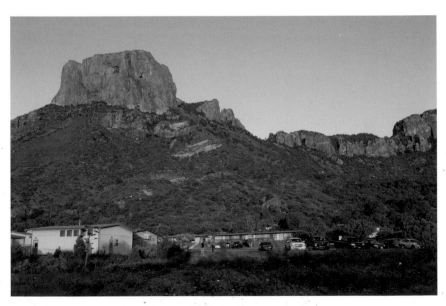

Include the Chisos Mountains Lodge in the photo to put Casa Grande in context with its surroundings.

From your position, balance the light meter for the scene using f/16 for maximum depth-of-field and then the shutter speed necessary to put the scale in the middle. Alternative, use aperture priority with f/16 and let the meter balance on its own.

Place your focus point one-third of the way into the scene versus right on Casa Grande. A focus point one-third of the way into the scene will usually maximize your depth-of-field since the area in focus goes one-thirds forwards and two-thirds backwards. If you're super meticulous, use your depth-of-field preview button or a hyperfocal distance chart to set your focus point. (See hyperfocal distance in the glossary.)

Lock the camera down on the tripod and take the picture. A shutter release or the self-timer on the camera will ensure a sharp photo.

Season: Any time of the year is good.

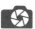 *Photography Hint*

A polarizing filter reduces glare in a scene. As a result, colors are clearer or even enhanced. A polarizing filter works wonders to bring out the colors in Casa Grande and enhance the color in the sky. Rotate the filter while

A polarizing filter enhances the colors in Casa Grande and brings out the color in the sky.

looking through the viewfinder to find the best position for the filter. A polarizer works best with side lighting. If you rotate the front element of the filter completely and nothing changes in your photo, change your angle to the sun. Remove the filter if you don't see a difference despite rotating the filter and changing your angle to the sun.

The Window Trail

This is one of my favorite trails. The scenes at the bottom of the trail are great. The journey there is a delightful downhill walk. The trip back is uphill with the last section in the sun. Plan your trip with that in mind.

The end of the 2.2-mile-long trail contains a narrow canyon with slick walls polished smooth by years of rushing water. All the rainwater from the Basin flows downhill and eventually makes its way through the pour-off at the end of the Window Trail. The pour-off looks out on the desert and makes the view spectacular.

The best time for photography is early in the morning or late in the afternoon. These are the times when all the smooth areas are in the shade. Arrive at the wrong time and half the canyon is in the blazing sun and the other half is in shadows. To add to that challenge, the view of the desert can be bright. In general, high contrast is not conducive to good photography, but this is a great opportunity for high-dynamic-range photography. Remember to pack your tripod if you're going to try this type of photography.

A wide-angle lens in the 18mm range is necessary to get both walls of the canyon in view. Wider is better particularly if you'd like to include something interesting in the foreground.

Simple: Adjust your camera so that it captures the widest view possible. Kneel down on the ground or squat so that there is some foreground in the bottom of the frame. Be sure to turn on your flash if you're going to put your traveling companions in the photograph.

Intermediate: Compose the photograph so that it is symmetrical, with both sides of the canyon filling equal amounts of the photo. A horizontal composition will show how wide the pour-off is. A vertical composition will show how steep the canyon walls are.

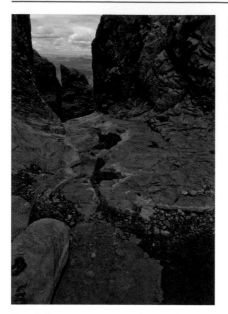

Kneel down or squat to enhance the foreground.

The Window Trail pour-off in symmetrical composition.

Advanced: Determine your composition and then put your camera on a tripod and lock it down. Texture in the smooth rocks makes an interesting foreground. Select the evaluative/matrix light meter to read all the light in the scene. Put the camera in aperture priority with an f/16. Select a focus point that allows the camera to focus a third of the way into the scene to maximize your depth-of-field. To capture all the tones of light in this canyon with complex lighting, consider an HDR photograph. High-dynamic range or HDR is a computer blending technique that works well in situations with a wide variety of tonal ranges. To capture an image in HDR, bracket five photos, from two stops over exposed to 0 to two stops under exposed, without moving the camera. Blend the images later in software designed for high-dynamic-range photography like Photoshop, Photomatix, or Nik Efex Pro.

 Photography Hint

This hike is really popular with family groups because school-age children can make the journey without too much difficulty. As a result, family groups gather in the pour-off to enjoy a picnic lunch and take pictures. Start your hike early to beat the crowds and enjoy the pour-off with just you and your camera.

Lost Mine Trail

The Lost Mine Trail is one of the most popular hikes in the park. The trail is mostly uphill and culminates at a slick rock outcrop perfect for a picnic lunch, sunbathing in the winter, or taking pictures.

There are several places along the trail that offer great landscape photo opportunities. My favorite is about a mile up the trail where the view opens to include the back of Casa Grande and the low desert in the distance.

Simple: Keep your back to the sun so light is falling on your subject. Avoid shooting directly into the sun if you're on the trail in the morning.

Intermediate: Carry your tripod on the hike and try your hand at taking photos with f/16 or f/22. Those are each a small opening in the aperture of the lens, which gives the large depth-of-field. That small opening also means only a small amount of light hits the sensor and a long shutter speed is required. The resulting images should show a large area in focus.

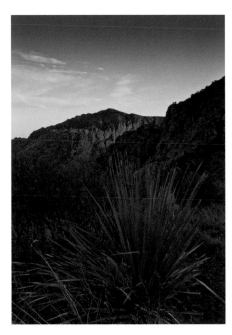

Advanced: Hit the trail well before the sun comes up. Be in position with your tripod and camera so that you have a view of the valley at first light. Work fast with the camera on aperture priority and f/16 to capture the valley before the sun is too strong and light too contrasty. A rectangular split neutral-density filter, positioned on the front of the lens so that the line between gray and clear is on the ridge of the cliffs on the far side of the valley, helps to block the bright light in the sky. In the finished photo, there's a nice balance between foreground and sky.

Sunrise on Lost Mine trail.

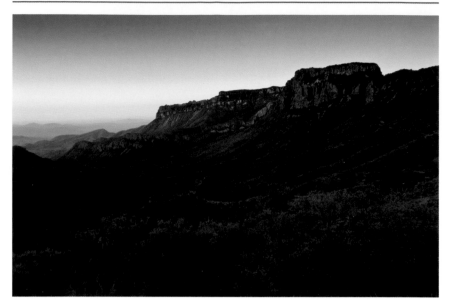

F/stop setting of 22 yields a wide depth-of-field as the sun rises on Lost Mine trail.

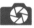 *Photography Hint*

At sunrise, light flows into the valley like a spotlight. The first rays of light hit the rocky outcrops on the opposite side of the valley. I use a two-stop soft-edge split neutral-density filter to balance the light from the sky with the darker foreground on the mountainside. The key is to balance your light meter in the partial or spot mode on the mountainside. This is also a good location for a high-dynamic-range photograph.

General Basin Photography

The Basin is filled with photography opportunities. Any walk with a camera yields something to photograph. My favorite trails are the Basin Loop Trail and the trail from the Basin to the campground. But a walk around the perimeter of the parking lots around the store and restaurant always yields photo opportunities.

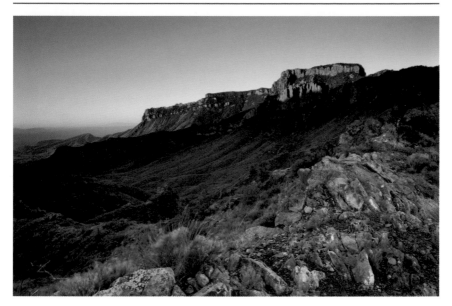

A split neutral density filter is used in this photo to balance the light between the sky and foreground. The meter reading is on the foreground using the spot or partial light meter. The sky can't factor into the exposure because it will negate the benefit of the split neutral density filter.

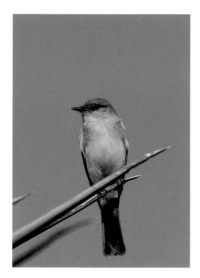

Say's phoebes are common in the Basin.

Birds

A wide variety of birds make their living feeding on insects and seeds around the parking areas in the Basin. Cactus wren, Say's phoebe, and canyon towhee can be found perched on a yucca at any time of the day. Walk slowly and quietly to get close to the birds. Avoid walking directly up to them. Rather, take a few steps, take a picture, stand, take a few more steps, stand, and take a picture, until you're close to the bird. Most birds in the Basin are habituated to people, but take your time. If you miss one, try again with the next bird.

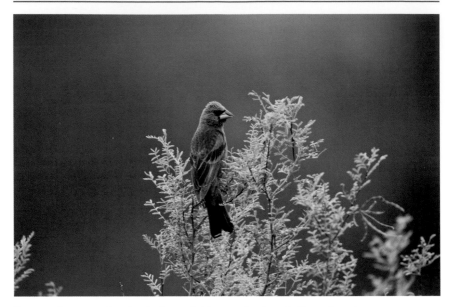

Summer is a great time to photograph blue grosbeak and other migrants.

Watch for greater roadrunner around the rocks near the restaurant parking lot. Turkey vultures are overhead most days. Summer is a great time to see Scott's oriole, blue grosbeak, and maybe a hepatic tanager.

Wildflowers

Wildflowers bloom on the edges of the parking lots in the Basin and along the trails. Photographs of wildflowers look best when taken from eye level with the flower. Kneel down on the ground, squat, or find flowers that are elevated along the trails. Get as close as your camera will allow to fill the frame with the blooms. Back away to include the leaves if you're going to identify the flower later. Watch that the shutter speed is fast enough, 1/60th or faster, to stop the movement of a swaying wildflower. A tripod is always helpful when working close to a subject.

Butterflies

High-mountain butterflies are all over the Basin in the warm months. Red satyrs flit along the trails and always stay low to the ground. They are hard to approach so be patient and keep trying. Two-tailed swallowtail and pipevine

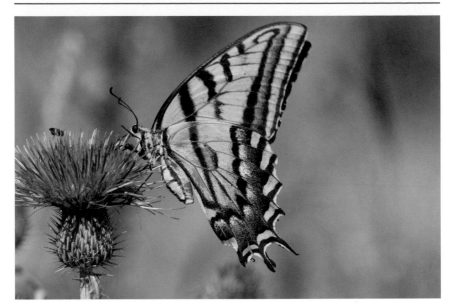

Look for two-tailed swallowtails around summer thistle blooms.

swallowtail are common summer butterflies at the thistle bushes behind the Basin Store. Acmon and Ceraunus blue might be found on the wildflowers around the parking areas. Southern skipperling, great purple hairstreak, gray hairsteak, and other butterflies are drawn to blooming beebush in the summer. California sister and variegated fritillary are found out on the trails.

Geology

Big Bend is all about geology. In the Basin, there are big examples of geology and small examples. Rocks with interesting colors and patterns are used in walkways, on fences, and in walls. Photograph the fossils in the stones that make up the restaurant and gift shop. Pour water on the colorful flat rocks near the visitor center to bring out the color.

Mammals

Carmen Mountain white-tailed deer, a small species of white-tail isolated in the high mountains by the last ice age, come out to feed in the open areas around the parking lots. Walk slowly and avoid yelling, and they will let you get fairly close.

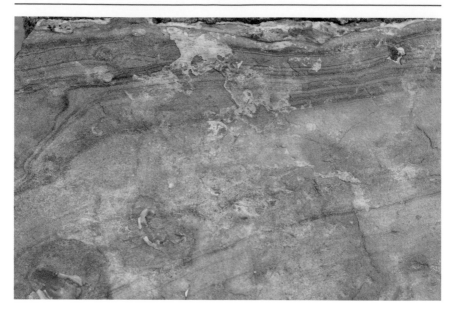

The beauty of geology found in a rock decorating a walkway in the Basin.

Javelina, or collared peccary, come out into the parking lots to feed. Many people think these pig-like mammals are dangerous, but they aren't. They are near-sighted, though, so they startle easily. Once again, be quiet and approach quietly for good photos.

Rock squirrel live among the rocks that line the top parking lot for the restaurant. They are about as big as a

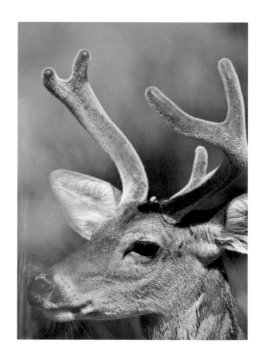

White-tailed deer so close it's hard to fit the antlers in the photograph.

small house cat and have a gray body with darker head. Look for them on rocks and listen for their loud alarm call.

Gray fox and striped skunk come out at sunset. Watch for them behind the hotel rooms in the evenings. Striped skunks usually won't spray a person unless threatened. Keep your distance and don't make quick moves. ■

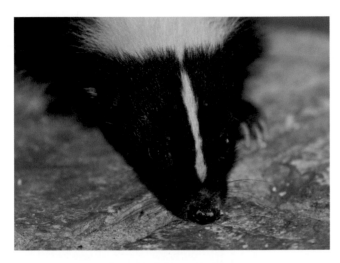

A flash helps to capture the action of a striped skunk hunting for food at night.

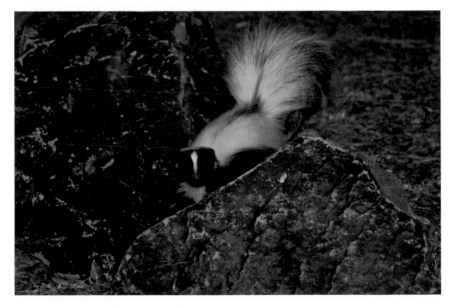

2 Panther Junction

P ANTHER JUNCTION is the park headquarters. It's made up of a visitor center, ranger station, restrooms, post office, and administrative offices. Panther Junction is the starting point for several photography outings.

Panther Nature Trail

There is an accessible, paved nature trail adjacent to the visitor center that is perfect for macro or close-up photography. Most visitors zip through the trail in two or three minutes but photographers can spend an hour or more on the trail.

The trail is a great way to learn the common plants, cactus, and shrubs that you'll find in the park. Each is labeled, but it's best to buy the trail guide. The guide gives common name, scientific name, and a little information about each plant.

Simple: Figure out how close your camera will focus. Hold your hand in front of the lens and move your hand forward until the camera will no longer auto focus. Photograph blooms and plant details at this distance while concentrating on filling the frame with the subject. Take some photos of the entire plant for variety.

Intermediate: Determine the minimum focusing distance for your lens as above. Many wide-angle lenses, like an 18–55mm or a 17–85mm lens, will focus remarkably close. Fill the frame with a cactus bloom, seed head, or with the fibers along a yucca leaf. A tripod will help to hold your camera steady and help reach unusual angles. Shoot between the f/stops of 5.6 and 11 depending on the depth of the subject.

The Panther Junction Nature Trail is a great place to work on macro photograph.

Advanced: Break out the macro photography equipment and have fun on this trail. Add an extension tube to any lens to get closer to the subject. Screw a close-up diopter, or close-up filter, on the front of any lens for added magnification. Use an extension tube with a close-up diopter for unworldly images of tiny subjects. Remember to use a sturdy tripod to minimize vibration. At ultra-high magnification vibration is exaggerated. Add light to the subject by opening a reflector to reflect light into shadows. Use a flash to illuminate the entire scene or add light from a specific direction.

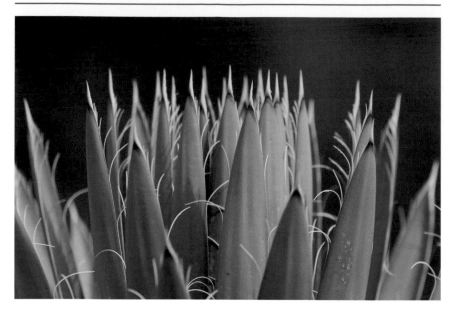

Repeated patterns on a yucca make for an intriguing photograph.

Season: Cacti bloom from March to October, so there is usually something in bloom along the trail. Cacti bloom during the heat of the day, so don't expect early morning blooms. Wildflowers can be found during most of the year but primarily February to November. Cactus spines, threads on yucca leaves, and other plant details are available all year.

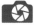 *Photography Tip*

Photograph the plant name or the number that corresponds with the trail guide. Photographs have more meaning when we know the name of the main subject. The names are also helpful if the photos are used in a slide show, book, or article.

Dagger Yucca

Dagger yucca are one of the magnificent plants that grow in Big Bend National Park. Plants can reach ten feet with bloom stalks containing hundreds of blooms and weighing up to seventy pounds. Blooms appear in the spring and early summer, primarily March to May.

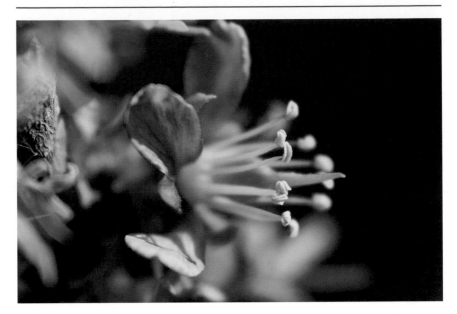

The tiny bloom of a javelina bush is photographed with the aid of a close-up filter.

Dagger Yucca can be found throughout the park along with Torrey yucca and twisted leaf yucca. The blooms are a delicacy in Mexican cuisine.

There are several nice yucca specimens at the Panther Junction Visitor Center. Look for them along the roadways in the park and also around the hotel in the Chisos Basin.

Dagger Flats Auto Trail is a six-mile gravel road in the northern reaches of the park. This road is a great place to photograph yucca when the plants are in bloom. You'll find yucca all along the road and a big concentration of plants at the end of the road.

Simple: Yucca are an upright plant so they make an excellent subject for a vertical photograph. Rotate your camera so it is vertical, and fill the frame with a yucca. Be sure to leave some room around the top and sides so that the subject has room to "breathe."

Intermediate: Yucca add context to a photograph of the Chihuahua Desert. Look around for a scene where you can place a yucca in the lower left corner of the frame and mountains or desert in the rest of the photograph.

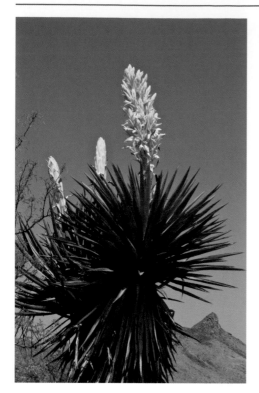

Dagger yucca simple Dagger yucca advanced

The base of the yucca should be in the left corner but not so close as to cut off the yucca leaves. Your focus point should be on the yucca.

Advanced:

Yucca are a great subject to silhouette against the morning or evening sky. Take a meter reading off the scene and then underexpose by one stop. This should yield a sky filled with color and the yucca black. Select a single yucca or group of yuccas that are separated enough so anyone looking at your photo will know the dark objects are yucca plants. Blobs of dark things make rotten silhouettes.

Season Blooming season is March through May, but the plants retain their beauty and wonder throughout the year. Seedpods that form on the plant in the summer have an interesting structure. When those seedpods dry in the

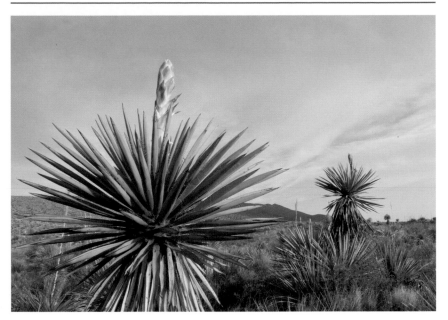

The strong placement of the yucca in the foreground enhances this photograph of the landscape.

fall and winter, they yield a new look. The broad leaves of a yucca hold a lot of snow during rare winter snowstorms.

Photography Tip

There are amazing things going on around a yucca plant. It's a host for a variety of insects, so poke around a plant to see who is lurking inside. Watch out for the point on the tip of every leaf. It's sharp!

Get down low and photograph up at the yucca. Photograph down the leaf of a yucca. Take close-up images of the individual blooms.

Sunrise in the Desert

The three-mile road from the Panther Junction Visitor Center west to the Chisos Mountains Basin Junction is a great place to photograph the sunrise. Park your vehicle in one of the pull-offs on the south side of the road facing the Chisos Mountains. Arrive well before sunrise to photograph the mountains and desert in the soft morning light.

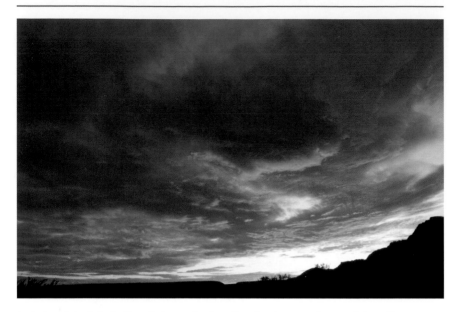
Include a lot of sky in the photograph when the clouds and colors are interesting.

Simple: Stand along the edge of the road and zoom the lens on your camera to its widest field-of-view. If there are interesting clouds in the sky, then include a lot of sky in the image. Include only a little sky if there are no clouds or the sky is only blue.

Intermediate: Step out into the grass of the desert. Place your camera on a tripod, aperture priority, f/22 for maximum depth-of-field, and evaluative/matrix light meter. Compose the scene so that there are mountains in the background with grasslands in the foreground. Focus a third of the way into the scene. Use the camera's timer or a shutter release to trip the shutter. This should yield a sharp photograph with maximum depth-of-field.

Advanced: Walk through the grasslands to find a prickly pear with pads facing the sun or a sotol plant that's in good shape. Compose the scene so the prickly pear or sotol is in the bottom left corner of the scene with your lens at its widest field of view. Lenses in the 12mm, 16mm, or 17mm range are perfect for this composition. Adjust your camera per the instructions above for an intermediate photo. Photograph in the minutes before and after

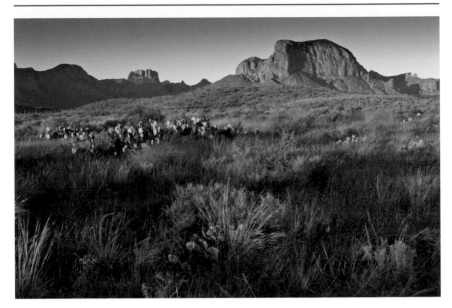

The focus point in this image is on the vegetation in the foreground. The viewer's eye is drawn to that point first. Then the view can look around the image at the grasslands, mountains, and sky.

sunrise for beautiful lighting on the grasses and mountains.

Season: Any time of the year is good for this location. It also makes a nice sunset location.

 Photography Tip
Tilt your camera down at the ground ever so slightly to maximize the depth-of-field. This tilt, maybe 20 to 30 degrees off perpendicular to the ground, makes the foreground appear bigger and the background recede away.

Tilt the camera down to accentuate the foreground.

Dugout Wells

A small spring at Dugout Wells creates an oasis of cottonwood trees, sumac, mesquite, and beebush. Early settlers had a school here, but today it's just a nice stop with exhibits, cactus, wildflowers, a windmill, and of course cottonwoods. There are also picnic tables and restrooms so a photographer could be happy at this location for a long time.

Across from the parking area is a self-guided nature trail. The gravel trail snakes along the sides of small hills. The change in elevation and cactus specimens make this a nice trail for photography. There's no shade, so plan on arriving in the morning or evening to avoid the heat of the day.

The cottonwood grove holds a lot of possibilities. The weathered bark of a cottonwood has captured the eye of photographers for years. Study the bark of these trees through the viewfinder of your camera to see what shapes and patterns you find.

If the sky is blue, or filled with puffy white clouds, turn your camera upward. Compose a photograph of yellow cottonwood leaves against a blue sky. Yellow and blue are contrasting colors so they always look good together. Green cottonwood leaves also work well. Gnarled, bare cottonwood branches in the winter photographed against a blue sky make an interesting black-and-white photograph.

Butterflies feed on the wildflowers near the parking area and in the bushes along the road behind the windmill. Look for Palmer's metalmark in the wildflowers. Queen, checkered white, and sleepy orange are found in the bushes along the road from April to October.

What photographer could ever resist a windmill? The windmill at Dugout Wells is positioned well for photography. It has a clean, unobstructed background with a nice view to the sky or mountains.

Simple: Be sure to keep your back to the sun no matter what your subject at Dugout Wells. Watch your shadow, as well, to make sure it doesn't show in your photograph or cast a shadow on your subject.

Intermediate: Arrive early or late in the day and photograph the cactus along the nature trail. Notice that there are many varieties of prickly pear cactus. Some have long curved thorns that make interesting patterns. The

Keep an eye to the ground for interesting photographic subjects.

blind prickly pear cactus has tiny thorns that could go unnoticed except when they are embedded in your finger or shin. Purple prickly pear cacti have deep purple pads and thorns especially when starved for water.

Advanced: Let's silhouette that windmill! This works best when the sky is blue and the sun is shining from late morning to late afternoon. Find a position where the sun is behind the windmill. Put your camera on a tripod and compose the photograph so the sun is behind the blades of the windmill. (Use the live view option on your camera so you can compose the image by looking at the screen on the back of your camera. It's not a good idea to look at the bright sun directly through the viewfinder.) Put the camera in aperture priority mode with an aperture of f/22. Underexpose the scene by one stop. Adjust your composition so the sun is just peeking over a blade of the windmill. If the blades of the windmill are turning this step isn't necessary since you'll try to click the shutter so that the sun is peeking through the blades as they turn. The f/22 will turn the sun into a star burst as it peeks through the blade of the windmill. Check your work on the rear display to see if you captured a starburst.

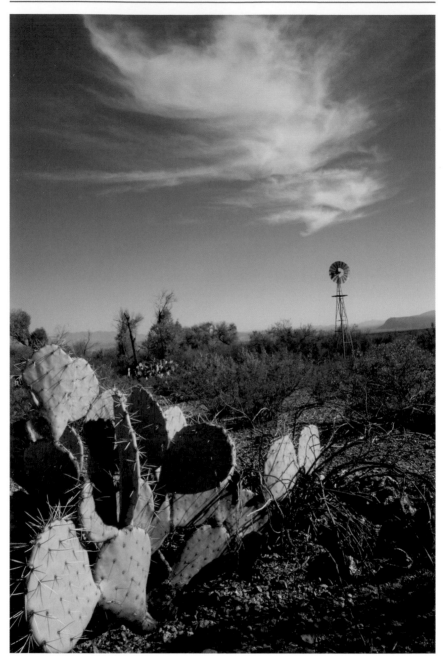

Cactus in the desert at Dugout Wells make an interesting foreground subject.

Season: Anytime of the year is good for Dugout Wells. Temperatures in the desert in the winter can be comfortable. Temperatures in the middle of the day in the summer can be brutal. Plan your stop at this location accordingly.

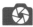 *Photography Tip*

Check for unwanted lens flares that can spoil an otherwise great photograph. Remove the "protective" UV filter as most of those do nothing more than cause lens flare. Modern camera lenses are made of tough glass that doesn't scratch and doesn't need protection under normal conditions. Lenses in the 1950s and 1960s were made of softer glass and needed protection. ■

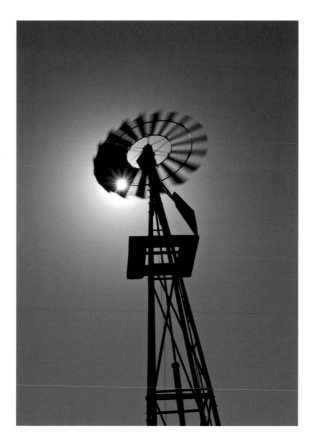

The starburst on the sun comes from setting the aperture to f/22. Use Live View on the back of the camera to compose the scene without having to look directly in the viewfinder.

3 Rio Grande Village

THE LOW DESERT on the east side of Big Bend National Park holds a wide variety of places to photograph. This area has a pleasant climate most of the year, but can be brutally hot during the day in the summer. Visitors in the winter months flock to this area, so it can get crowded.

Hot Springs

Hot Springs was a place of rest, relaxation, and healing in the early part of the twentieth century. The motel rooms gave travelers a place to stay and enjoy the clear desert air, while they luxuriated in the hot springs along the

The old store at Hot Springs holds a lot of photographic possibilities.

Rio Grande. The store and post office drew residents from both sides of the river. Today, the buildings are a testament to times long gone, and the area holds many opportunities for photography.

The average tourist heads straight to the hot springs at the end of the trail. Photographers should hang around the parking area and around the buildings.

Simple: Stand in front but slightly left of the old post office building. Frame your photograph of the old building so that the palm tree is in the scene. Fill the frame with the old building, palm tree, and a little bit of the rocky ground.

Intermediate: Native American pictographs adorn the cliff walls just past the old motel rooms. Follow the park service signs. Many of the markings are high on the walls so a lens in the 75–300mm range is needed to get close. The pictographs are in the shade so a tripod helps to get great photos. Place your camera on a tripod, compose the photograph, and lock the tripod securely in position. Set the camera on aperture priority and f/5.6 or 6.3 if the camera and rock face are parallel. Use f/8 or f/11 if the camera is at an angle to the

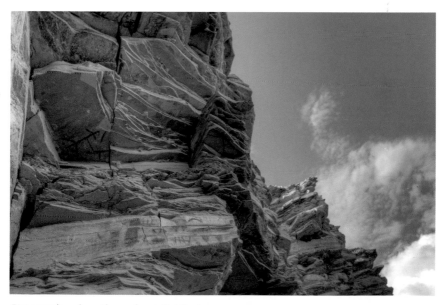

Pictographs adorn the rocks at Hot Springs.

rock face. (See "flat to the film plane" in the glossary.) Trigger the shutter with the camera's timer to reduce camera movement. No need to use flash.

Advanced: Hike up the small hill adjacent to the parking area to the ruins of Longfellow House. The windows and doors of the house make an excellent "frame" for the landscape nearby. Stand inside the house and shoot through the window opening with the cliffs along the Rio Grande in the background. A lens in the 16mm or 18mm range works well. Notice that there are excellent specimens of fossils in the stones used to build the house. A fossil near the doorway makes a great foreground subject for a photograph of the finely layered hillside along the river.

Season: Any season is good. The light is very contrasty during the middle of the day in summer.

 Photography Tip

Check out the paintings on the walls of the store and motel rooms. Etta Koch did these in the 1940s when she spent the winter in Longfellow House. Position your camera tight against the wire mesh that blocks the doorways

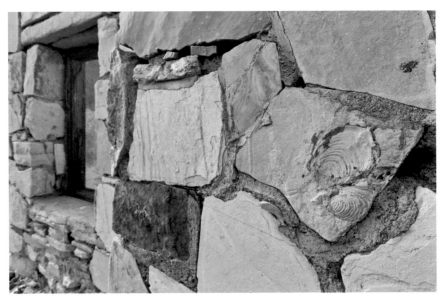

Fossils in the rocks of Longfellow House make nice compositional elements.

of the buildings. Turn on your flash and use that to illuminate the paintings. As an alternative, put your camera on a tripod and put the lens tight against the wire mesh. Adjust the light meter for the available light with a slow shutter speed. Trip the shutter with a shutter release or the camera's timer.

Daniels Ranch

Upriver from the store and RV parking area is the Daniels Ranch. Today, there is only an adobe house, but it is fun to touch, study, and photograph. A large grove of cottonwood trees stands nearby in a park-like setting. The Rio Grande is a short walk from the adobe house. As if that wasn't enough to capture the eye of any photographer, there is an overlook on the hillside with incredible views.

Simple: The adobe house can be photographed from a traditional straight-on view, but that is boring. Stand close to the walls of the adobe house. Find a vantage point where the light accents the texture in the walls with the sky in the background. Try to put a focus point on the adobe wall and the blue sky as a background. Tilt the camera so you get a dramatic angle.

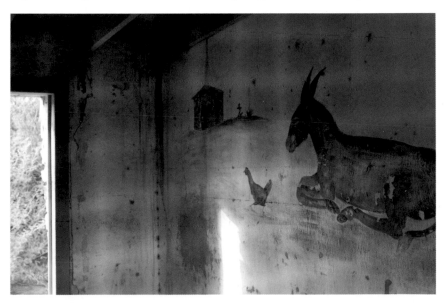

Etta Koch's paintings decorate the walls of the old store and motel at Hot Springs. The paintings are challenging but fun to photograph.

Intermediate: In the evening, light from the setting sun turns the face of the Sierra del Carmen deep pink. Find a place in the middle of the road or in the cottonwood grove where you can see the mountains. Place the camera on a tripod and frame the scene with a wide-angle lens. If standing in the road, use an f/22 on aperture priority for a photo with a large depth-of-field. Focus a third of the way into the scene to maximize that depth-of-field. Use a shutter release or trip the shutter with the timer on the camera for a super-clear image.

Advanced: The trailhead for the Hot Springs Trail is in the cottonwood grove. Hike the trail to the top of the bluff. Leave the trail BUT note your position because it's hard to relocate the trail on the way back. Walk across the bluff to the edge overlooking the river. Use a wide-angle lens in the 10mm to 16mm range to take a photo of the Rio Grande. Either direction is good depending on the time of day. Use a tripod for maximum depth-of-field and include the rock chips or cactus as an interesting foreground.

Season: Winter is the mildest, but summer skies can be spectacular.

 Photography Tip

The moon rises in the evening over the Sierra del Carmen when it is nearly full. Check the moonrise chart to see if you'll get a moonrise during your visit.

Rio Grande Village Campground

The campground is a great place to photograph wildlife.

Simple: Javelina usually walk through the campground in the morning and evening. They feed on seedpods that fall from the mesquite trees. A photo from eye level is better than one from standing. A photo that fills the frame with the animals is better than lots of space and a small javelina. Remember that javelina are near-sighted, so don't get too close and startle them. Avoid separating a mother from babies, as well.

Intermediate: Raven, turkey vulture, and greater roadrunner frequent the campground. Walk quietly around the campground with your camera and a lens in the 300mm range. When you spot a bird or critter, stand still. Let it get used to you and let it return to what it was doing. Then walk a little closer, stop, stand, and walk a little closer. The wildlife is habituated to people so will usually allow a close approach.

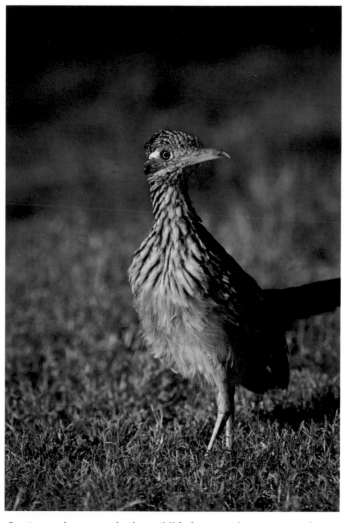

Greater roadrunner and other wildlife frequent the campground at Rio Grande Village.

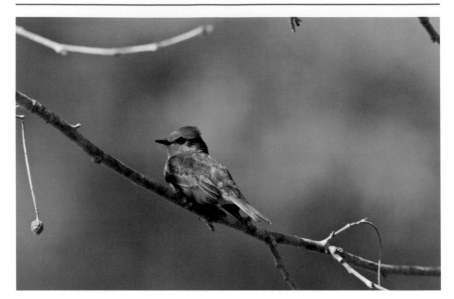
Use your car as a rolling photo blind to capture images of vermilion flycatcher.

Advanced: Vermilion flycatchers are beautiful, and one of the best places to see them is at Rio Grande Village Campground. They don't tolerate close approach, though. My recommendations are, first, to use your vehicle as a blind. Watch the birds to find their favorite perch. When the birds leave the perch to catch a bug, move a little closer to the perch. Wait, let them leave the perch again, then move a bit closer. Be patient and photograph with a long lens in the 300mm or 500mm range.

Season: Good any time of the year. Midday in the summer is really hot.

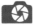 *Photography Tip*

Drive or walk the campground often. I've seen lots of great wildlife in the campground. I missed a lot of good photographs but also achieved a lot of good images.

Nature Trail

There is a nature trail adjacent to the campground. The trail includes a boardwalk that passes over a *cienega,* or freshwater pond.

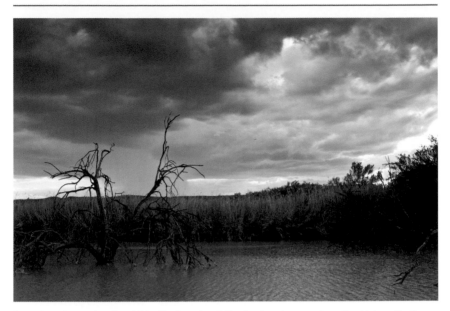

Looming storm clouds add to the beauty of the freshwater pond on the Nature Trail at Rio Grande Village.

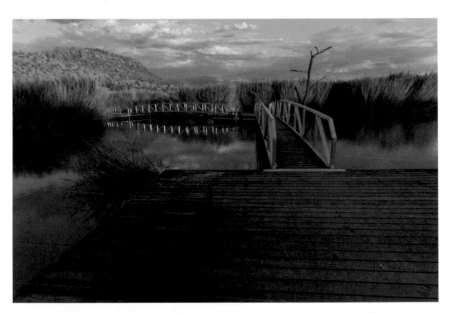

The boardwalk in the foreground draws the viewer's eye into this photo of the freshwater pond.

Simple: The view from the boardwalk looking at the dead trees in the walk is beautiful. Use a polarizing filter on your lens to get rid of the glare on the water. Compose a scene so you have water in the foreground, the dead trees, and then sky. If the sky is good with nice clouds, include more sky. If the sky is dull, include less sky.

Intermediate: Dragonflies love this pond in the summer. Flame skimmers are brilliant orange, and they can be common. Several other dragonfly and damselfly species make their home around the pond. Dragonflies are predators so approach them slowly so they don't fly away. Position your camera so it is parallel to the wings or parallel to the body. Look for males and females roosting in the vegetation around the trail entrance.

Advanced: The pond is magical at night. Stand on the boardwalk with your camera on a tripod. Frame a photo with the dead trees in the scene. Set f/stop and shutter speed to balance the light meter if there is some light in the sky. Otherwise, try 30 seconds at f/5.6. Use a flashlight to help you focus

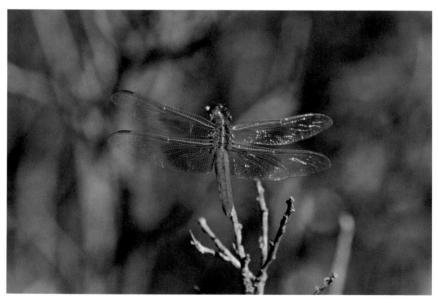

Flame skimmer and other colorful dragonflies can be found around the Nature Trail in the Rio Grande Village campground.

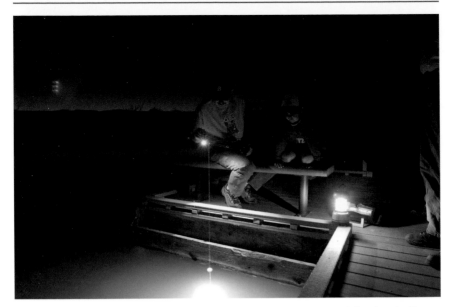

A father and son fish in the freshwater pond at night. A lantern carefully placed off to the right illuminates them.

on one of the trees. Click the shutter and use the flashlight or your flash off camera to illuminate the trees. This is called "painting with light" in the photography community. Be careful not to move around too much because the boardwalk floats and will shake the camera.

Season: Nature Trail is open all year and a great place to visit any time. It is hot on summer days.

 Photography Tip

The trail ends at the top of a small hill. That hill is a great vantage point for the sunset at any time of the year.

Boquillas Canyon

This narrow gorge is cut by the Rio Grande as it makes a wide bend around the Dead Horse Mountains and the Sierra del Carmen. There is a large sand deposit on one side of the river. The sand bar will be large or small depending on the water level in the river. The sandy area is a great

View of the Chisos Mountains from the hill at the end of the Nature Trail in Rio Grande Village.

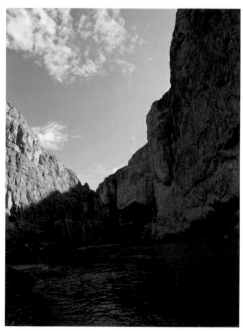

Boquillas Canyon including canyon walls and the river.

place to take pictures. The walls of the canyon contain a fault that is visible on the Mexican side of the river.

Simple: Stand at the entrance of the canyon and test the angle of view your camera will give you with the lens at its widest zoom. Photograph both walls of the canyon and the river if you can fit them in. Otherwise, photograph only one wall and the river.

Intermediate: The canyon needs a wide-angle lens to do

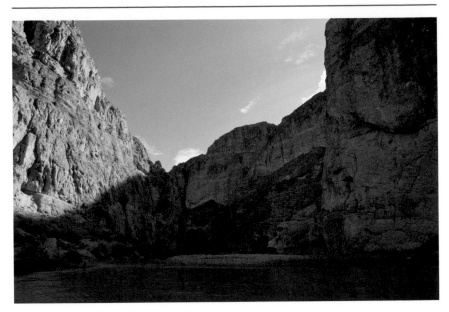

A wide angle lens is used to capture both walls of Boquillas Canyon.

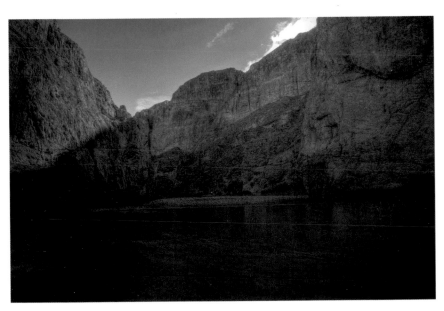

Contrasty light is hard to capture in a canyon. HDR, or high dynamic range, was used to capture all the tones of light from the sky to the river.

it justice. The walls are high, so a lens in the 12mm, 16mm, or 18mm range is needed to get a river-to-sky view. There is more distortion, bowing in or spreading out at the edge of the lens, if you compose the photo from low to the ground. There is less distortion if you stand up or shoot from a higher elevation. Work with the distortion to get a pleasing photograph.

Advanced: A photograph of a river looks better when the photographer stands in the water. The angle of view is different from what people normally see, so they are amazed. Place your tripod legs, or your feet if you're going to hold your camera, on the rocks in the river. Use a wide-angle lens to photograph the river and canyon walls. Add a polarizing filter to reduce or eliminate the glare off the river.

Season: Any time is good. The middle of summer can be dangerously hot, because it is humid along the river and the sand radiates a lot of heat. Overcast days work better since the light is softer and there is less contrast.

 Photography Tip

Photography around the Rio Grande is tricky in Big Bend National Park. The middle of the Rio Grande is the international border between the United States and Mexico. At this time, it is a federal offense to cross into Mexico in the park so be careful not to go near the middle of the river.

Overlooks in the Area

There are two overlooks in the Rio Grande Village area. One is immediately past the tunnel that cuts through the mountain on your way into the area from Hot Springs. The other is called the Boquillas Canyon Overlook and is off the road to Boquillas Canyon.

Simple: From the Boquillas Canyon Overlook you can see a small Mexican village named Boquillas del Carmen. At one time there was free trade with the village, and it was brightly painted. Today it is a bit dull and worn but still makes a great subject in a photograph. Include the village in the scene to put it into context.

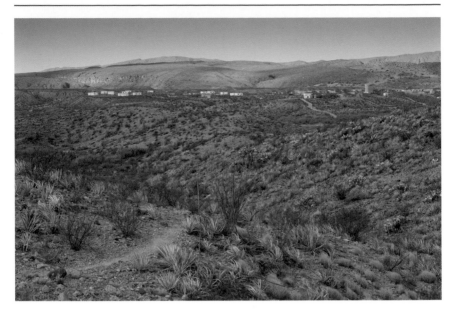
The small Mexican village of Boquillas del Carmen can be photographed from a convenient overlook.

Intermediate: The Rio Grande Overlook is good at sunrise or sunset. Stand anywhere on the overlook and use the light to your advantage.

Advanced: The Rio Grande Overlook is a great place to photograph the surrounding hills and valley under the full moon. The valley becomes saturated with soft light under the full moon when the sky is clear. Place your camera on a tripod and compose a scene. Set the ISO to 400, shutter to bulb, and the f/stop to 5.6. Hold the shutter open with a shutter release for one minute. Take a longer exposure if needed.

Season: Any time of the year.

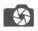 *Photography Tip*

This area is close to the river, so it is humid and can be hazy. It also can be hot in the summer. Select your photography time to overcome these conditions such as after a rain or on a crisp winter day.

The Rio Grande Overlook is a great place to capture the Chihuahua Desert at sunrise or sunset.

Tunnel

Tunnels are always fun to photograph, and the one at Rio Grande Village is no exception. It's not a long tunnel so light from outside fills the interior. Park your vehicle at the overlook and take some time to photograph the tunnel.

Simple: Stand on the side of the road and include the tunnel in your photograph of the layered rocky slope. It's okay to include the road in the photograph, but it shouldn't be the main subject so keep it small in the foreground.

Intermediate: Make the road the main subject of the photograph. Using a wide-angle lens, get down low to the ground or put your camera on a beanbag right above the roadway. Compose your photograph so the road looms large in the foreground and terminates at the tunnel.

Advanced: Take an HDR photograph through the tunnel with Sierra del Carmen in the view on the opposite side. Position yourself on the side of

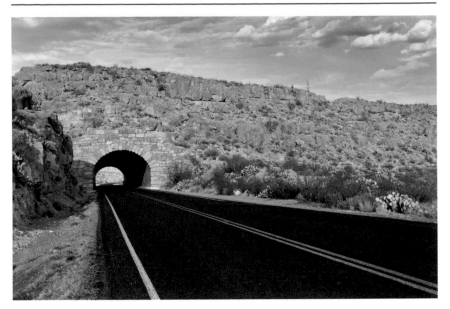

Stripes on the road lead the viewer's eye into the tunnel.

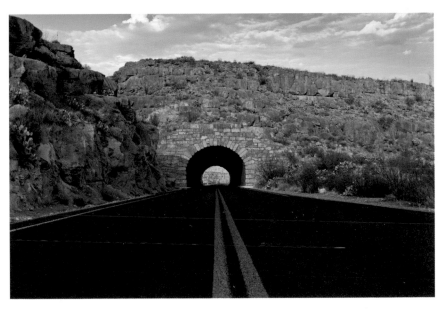

Center the road stripes and tunnel in the frame. Be sure someone is watching out for traffic.

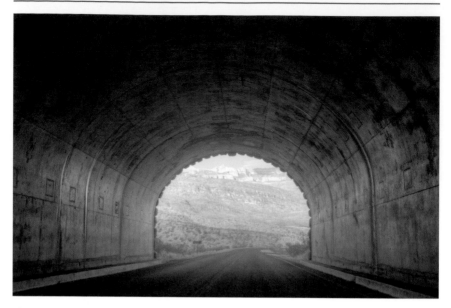

This is a high-dynamic range image or a blend of several photos taken at different exposures to capture all the light in a scene.

the tunnel opposite Rio Grande Village. My ideal position is inside the tunnel standing on the shoulder of the roadway. The camera is on a tripod and securely locked in place. Take a meter reading so that the Sierra del Carmen in the background are perfectly exposed. Then take five photos progressively darker until the interior of the tunnel is perfectly exposed. Process the images with Photomatix, Photoshop, Lightroom, or other HDR software.

Season: Any time.

 Photography Tip

I shoot my HDR images in jpg versus raw. The images aren't going to be processed but are used in combination to produce a final photograph. Therefore, we really don't need later RAW images. The jpg images are smaller files and work just as well. I photograph my hand at the beginning of an HDR cluster to let my brain know the following images are meant for HDR processing. I photograph my hand at the end of the series to let my brain know I'm finished. ■

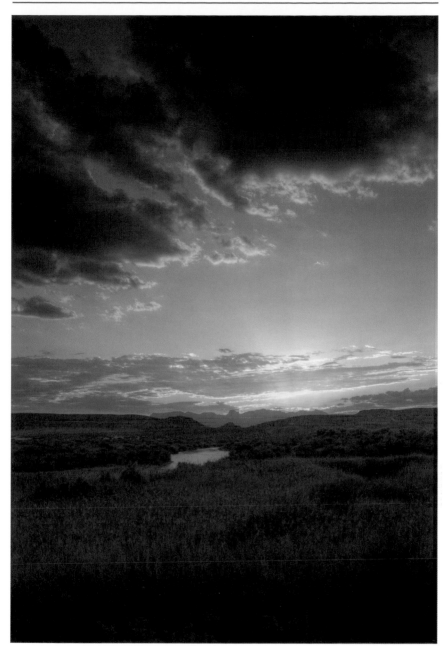

HDR, or high-dynamic range, blend of photos to capture the tones in a sunset from the Nature Trail at Rio Grande Village.

4 Ross Maxwell Drive

THIS SCENIC DRIVE was named for Ross Maxwell, the first super-intendent of the park and a famous Texas geologist. The thirty-mile drive winds past many of the most stunning geologic features in the park. Photographic opportunities abound, so allocate plenty of time for this section of the park.

Chisos Mountains View

You'll come to a pullout a mile and a half after passing the Santa Elena Junction on the east side of the road. The notch we know as the Window View and the Chisos Mountains loom large over the desert in front of you. This is a great place to get out of the car, enjoy the desert, and take photos.

Simple: The Window from this angle is beautiful. Casa Grande is visible past the window when the sky is clear. Compose your photograph following the rule of thirds. The desert is in the bottom third of the frame, the Window is in the middle third, and the sky is in the upper third of the frame.

Intermediate: Find an interesting cactus, rock formation, or cluster of wild-flowers. Get down low and place your find in the bottom left or right corner of the frame with the Window and Chisos Mountains in the background. Put your polarizer on the front of the lens, rotate it, and see if it cuts glare or haze in the scene. Remember to use f/16 or f/22 to give the photo maximum depth-of-field.

Advanced: The view of the Window from this vantage point is spectacular in the afternoon when sunset light bathes the mountains. Use this light to

Detail of a cactus found along the trail at Sam Nail ranch.

your advantage to accentuate the canyons, hills, and rocks. Wait a bit until the sun goes down and photograph the scene with a few stars in the sky.

Season: Any time.

 Photography Tip

This is a great late-afternoon location. Include a lot of sky when the clouds and sky are spectacular. Sky not spectacular? Include less sky and add more desert in the foreground.

Sam Nail Ranch

Sam Nail was one of the last ranchers to leave the area when the park was established. Desert plants have overrun the area, but we can still see fig and walnut trees, an old windmill, and parts of the adobe house.

Simple: Walk the trail leading to the wooded area. There are prickly pear cacti along the trail at a variety of heights. Look closely at the prickly pear to find things that are interesting to photograph. Notice that some specimens

All cacti in the desert are not the same. Notice the many different species of prickly pear cactus.

have long spines and some, like the blind prickly pear, have tiny spines. Work with the shadows on the spines or pads to create an interesting photo.

Intermediate: Stand where the trail begins right off the parking area. Find a place along the trail where you can see the trail, the vegetation, hills in the background, and the sky. Make sure there are no overhanging branches, twigs, or grasses that obscure your view. Look through your viewfinder and with a 16mm or 18mm lens affixed to the camera; position your camera about three feet off the ground. Ideally, the edges of the trail should hit the lower left and right corners of your photo. Tilt the camera down toward the ground a bit to exaggerate the width of the trail. Tilt the camera upward a bit to exaggerate the sky.

Advanced: Birds sing from perches on the top of mesquite, prickly pear, and yucca along the trail during the spring and summer. Stand quietly and listen. Figure out where the birds are perched and then slowly move into position. The brush is dense so it's hard to move through some places along the trail. I suggest a lens in the 400mm to 500mm range to bring the birds in closer.

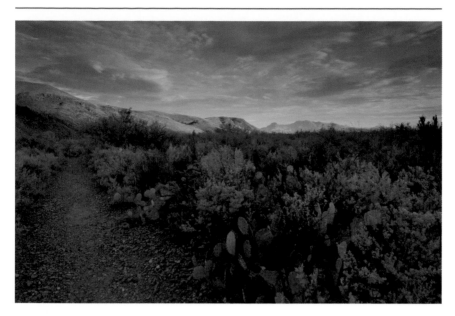

The trail at Sam Nail ranch is a great place to capture the desert landscape with a wide-angle lens.

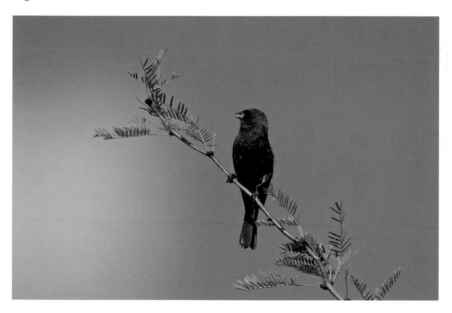

Varied buntings are reliably found in the summer around Sam Nail ranch. Watch the bushes and shrubs for a variety of birds at this location.

Season: Any time of the year.

 Photography Tip

Watch for distracting objects in the background of your photos. A photograph of a bird is best when the background is clean and clear. Landscapes should have no distracting utility wires or odd sticks poking up. Scan the viewfinder before clicking the shutter button.

Sotol Vista

The view from the top of this sotol-covered hill is magnificent. Once you drive to the top, park your vehicle and get out; you'll understand why the park gave us this area.

Simple: The exhibit area is a nice place to stand and take pictures of the surrounding landscape from an elevated vantage point. Look to the west and notice that you can see the mouth of Santa Elena Canyon.

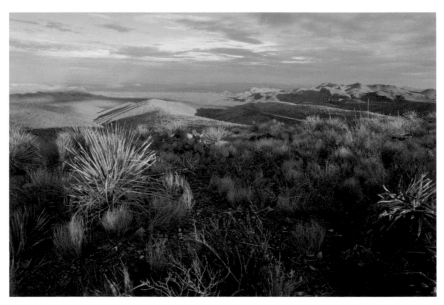

Sotol Vista offers a magnificent view of the surrounding desert landscape.

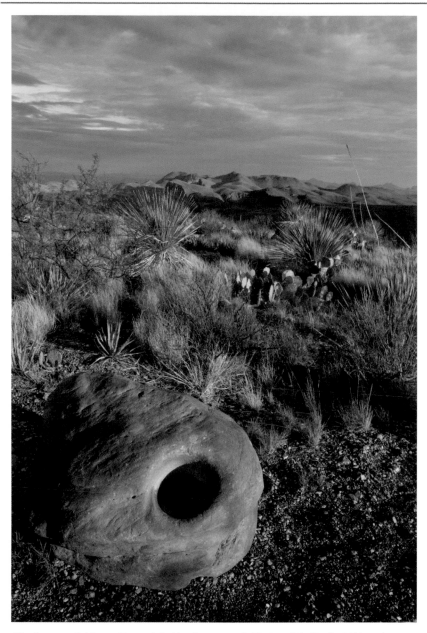

The focus point is on the rock in the foreground. That rock is the first thing viewers will notice. Then their eye will move through the scene looking at the grasslands and mountains in the distance.

A more dynamic photograph is created thanks to the interesting rock in the foreground and low camera angle.

Intermediate: Put your camera with a wide-angle lens in the 16mm to 24mm range attached on a tripod. Face to the west and compose your landscape photo so one of the rocks with a *matate* (hole used to grind grain by ancient people) is in the foreground. Set the f/stop to something in the f/16–32 range. Balance the camera's light meter with the appropriate shutter speed or use aperture priority so that the light meter will balance on its own. Focus about a third of the way into the landscape to maximize your depth-of-field.

Advanced: Same as above but really push the scene. Use a lens in the 10mm to 16mm range. Put your tripod low to the ground to accentuate the foreground. If there are great clouds in the sky, tilt the camera up to exaggerate the flow of the clouds. If the sky is hazy, tilt the camera down to exaggerate rocks or plants in the foreground.

Season: Any season. This is an interesting place to watch summer thunderstorms roll across the park. Heed flash flood warnings because Ross Maxwell Scenic Drive does flood.

 Photography Tip

Put your polarizing filter on the lens to see if it helps reduce glare and enhance the sky in this area. Check the histogram for your finished photograph to ensure you captured all the tones with no blown-out areas.

Burro Mesa Pour-Off

Stop your vehicle when you turn off Ross Maxwell Scenic Drive to Burro Mesa Pour-off. The geology in front of you is amazing to see. Ash deposits from volcanoes in the Tertiary period have been eroded and weathered.

Simple: Take photos of the grand landscape from this place on the road or drive forward to look for a good vantage point. Remember to include more of the sky if it is filled with wonderful clouds.

Intermediate: There is a parking area at the base of the mesa. Yucca, sotol, and prickly pear cactus grow around the edge of the parking area. Use a nice specimen of one of these plants in the lower right or left corner of your photo of the mesa. A lens in the 14mm to 20mm range will serve you well.

When the sky is interesting, angle the camera up to accentuate the sky.

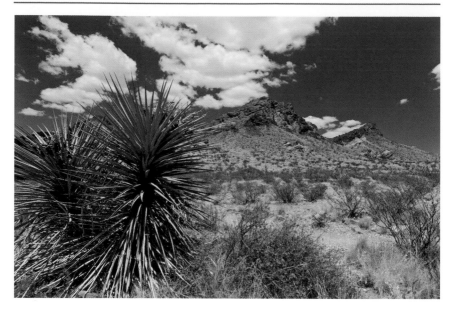
Foreground objects, in this case a pair of yuccas, enhance a landscape photograph.

Advanced: Let's get on the trail that leads to the pour-off. It's only a one-mile round trip, but travel light. Take your tripod, flash, and wide-angle lens in the 10mm to 20mm range. The trail takes you along the edge of the mesa where you can see rounded rocks and boulders embedded in the volcanic ash flow. (This ash flow might have reached speeds of 80 miles per hour to carry the boulders.) Rocks polished by years of rain await you. At the end of the trail, take pictures that you will combine later in high-dynamic range software. Take pictures that cover 360 degrees and blend them into a panoramic image later. Use your flash to illuminate shadows on a single dramatic image. Let your imagination flow in this area. It's magnificent.

Season: Any. There are more people in this area from fall to spring.

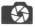 *Photography Tip*

This is a geologically rich location so include the geology in your photos. ▪

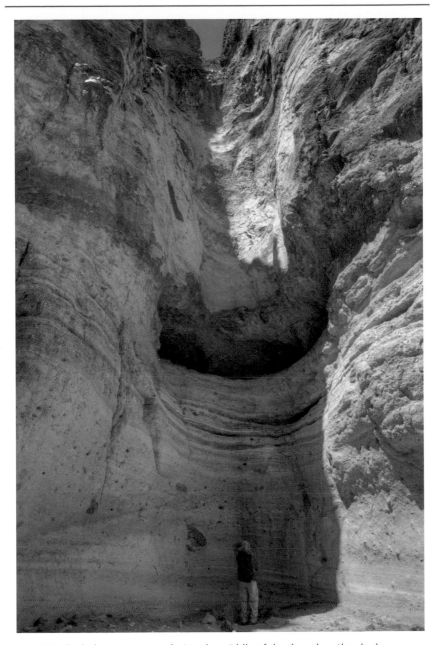

Use HDR, high dynamic range, during the middle of the day when the shadows and bright areas are intense.

5 Tuff Canyon to Santa Elena Canyon

MOUNDS of solidified volcanic ash, flat river plains, and towering limestone cliffs make for stark contrasts around the small settlement at Castolon. Erosion over millions of years allows us to walk through canyons in the area while mountains and cliffs tower overhead. Contrasts make photography fun, and this area is filled with them.

Tuff Canyon

Layers of volcanic ash spewed from the Sierra Quemada volcano during the Tertiary period. Hills of tuff, or compacted ash deposits, line the road from Tuff Canyon Overlook to the base of Cerro Castellan. This is a great photography area, so have fun and enjoy the sights.

Simple: There is a pullout at a low point in the road at the base of Cerro Castellan. White hills of tuff are on each side of the road. Photographic opportunities are endless, but most people head for the intrusion on the west side of the road that looks like a fossilized tree trunk. It even has a big hole that looks like a knothole. The hike to the intrusion is hard, but good photos can be taken from the lower hills that surround the formation.

Intermediate: The rocks around this pullout have been oxidized by the sun and are covered in "desert patina." This gives them a uniform dark brown color. The result is stark white tuff with small clusters of dark rocks. Walk along and look for patterns and shapes that are pleasing to the eye. Check your exposure by looking at the histogram on the back of your camera. A good histogram stretches from the left corner to the right corner of the histogram. It's key in this area not to over-exposure the white rocks, so watch

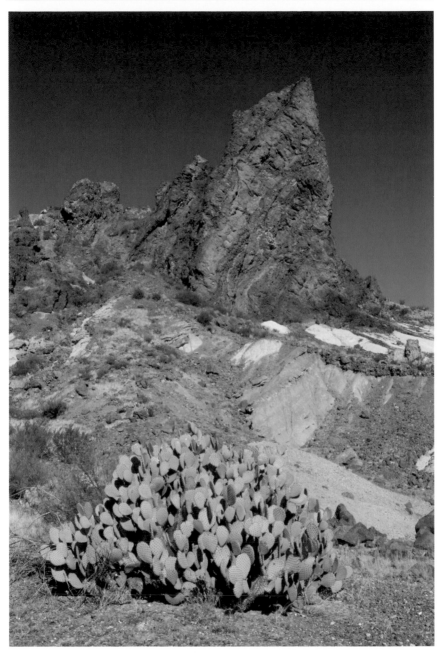

A pullout near Cerro Castellan is a good place to park and explore mounds of ancient volcanic ash.

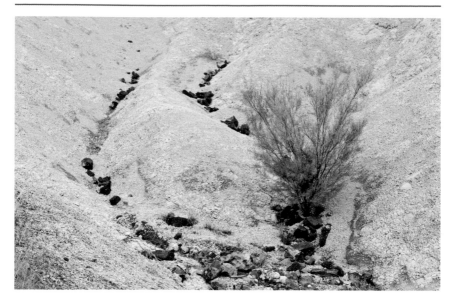

Play with lines of dark rocks against the ancient white ash to create interesting compositions.

for a spike up the right side of the histogram and blinking on the highlight indicator.

Advanced: Take advantage of any of the pullouts from Tuff Canyon Overlook to Cerro Castellan to park your vehicle. Get out and walk while looking for interesting images. The hike into Tuff Canyon allows you to see walls of tuff with multihued layers and embedded rocks. At the River Road junction there are pink tuffs with great scars created by years of erosion. There's a small opening cut into a basalt intrusion farther along the road to Cerro Castellan. Use your polarizer if shooting during the day to cut the glare on any rock surfaces and enhance the color of the sky.

Season: Any, but fall to spring are the most comfortable.

 Photography Tip

Diagonal lines in a photo are very aggressive. Yet many people overlook diagonals when composing an image. A line of dark rocks running from the lower left corner of a photo to the upper right against white tuft can produce a nice photograph.

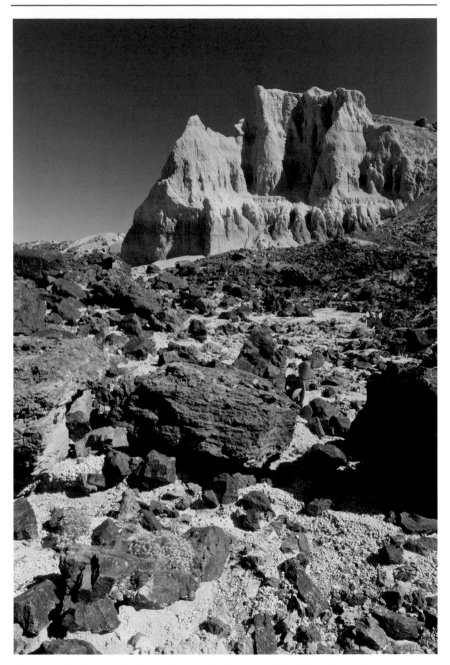

A splash of yellow makes for an interesting foreground in this photograph.

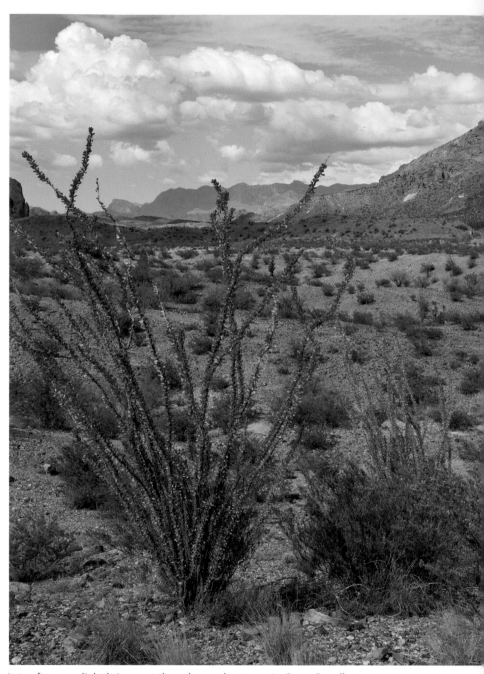

Late afternoon light brings out the colors and patterns in Cerro Castellan.

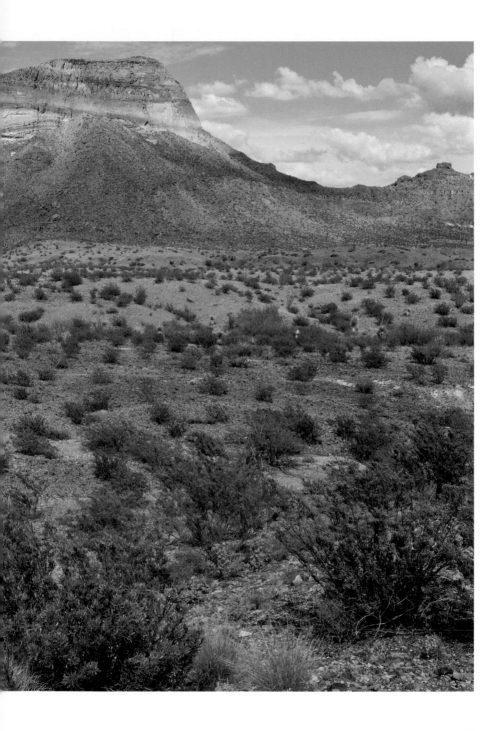

Cerro Castellan

Notice that Castellan, the mountain, and Castolon, the village, are spelled differently. Cerro Castellan is a multihued mountain that stands like a sentinel in the middle of the desert. Early settlers to the area used it as a marker. Today, it draws photographers from far and wide.

Simple: There is a pullout between Castolon village and Cerro Castellan on the south side of the road that offers a wonderful view of the mountain. The late afternoon light bathes the face of the mountain and brings out all the colors in the rocks.

Intermediate: From Castolon village there is a view of the mountain with a weathered, wooden building. Use that building to create an image showing the hand of man in the desert landscape.

Advanced: Cerro Castellan has many different angles that can be captured by walking out into the surrounding desert or climbing up on nearby hills. I like the morning light on the mountain with the white mounds of volcanic

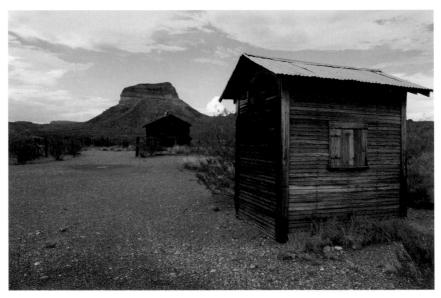

The weathered, wooden buildings at Castolon make interesting foreground objects.

ash on the north side. The south side is always pretty in the afternoon from the desert with a super-wide-angle lens in the 14mm to 16mm range.

Season: Any, but fall through spring are the most comfortable.

 Photography Tip

A polarizing filter usually works to reduce glare on Cerro Castellan. Rotate the filter when it's on the front of your lens. If you see a nice change in the image, keep it on. No change, take it off.

Castolon Historic Site

The buildings at Castolon were originally built to house the U.S. military. They were never used for that purpose but have housed a store since the 1920s. The store is called La Harmonia, meaning "the harmony" in

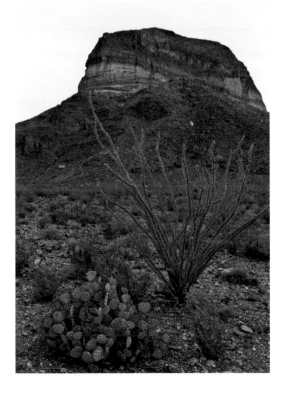

Walk out into the desert around Cerro Castellan. Use cactus or ocotillo as foreground objects to draw the viewer's eye into the photograph.

Spanish. It was a fitting name back in the last century when the store was a place where neighbors and family came together from both sides of the river. Today, there is a store, visitor's center, and outdoor display area.

Simple: Place your family or friends on the bench outside the front door of the store. This area is in the shade so it's easy to get a photo any time of the day. Frame your photo so that the screen door and the name above the door are included with the people on the bench. Put yourself in the photo by using a tripod to hold your camera and the self-timer to trip the shutter.

Intermediate: Notice the old mining equipment on the bluff near the parking lot. The equipment holds endless photo possibilities. Use a wide-angle lens, a macro lens, or a telephoto lens to capture details in the equipment. There are lots of details including the manufacturer's name, rusting metal, and machining details from the last century.

Advanced: This is a great place for a panoramic image. Stand in the middle of the parking area equal distance from the store and houses. With your

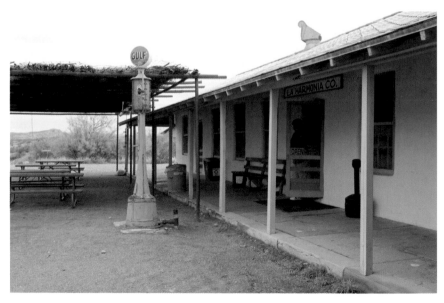

La Harmonia store at Castolon is loaded with history and photographic possibilities.

camera in the manual mode, get a meter reading. Rotate your camera vertically. Take twenty or so overlapping photos over a 90-degree area. Be daring and take overlapping photos in a complete circle or 360 degrees. Don't move, and take a second round of photos but aim a bit higher in the sky and overlap those images in your mind with the first set of photos. Take a third round of photos including more of the ground. Stitch the images together in Photoshop or another program designed to create panoramic images.

Season: Any time.

 Photography Tip

Panoramic images can be taken with any camera. The key is processing with software like Photoshop or Lightroom. No special equipment or tripod is needed. Simply take note of the horizon line. You want to keep the horizon level in all your photos. Set your camera in manual mode and set the light meter for one area of the scene. Keep autofocus on and let the camera autofocus with each image. Physically rotate your feet as you move through a 90-degree or 360-degree arc. This prevents sloping images that trail downward versus staying level.

Cottonwood Campground

Tall cottonwood trees in a grassy meadow give Cottonwood Campground its name. The trees attract birds throughout the year. The grass and scattered wildflowers attract butterflies, rabbits, turkey, and the occasional bobcat or coyote.

Simple: Walk along the road that circles the campground. Look for butterflies, interesting leaves, grasshoppers, or wildflowers in the grass. Butterflies flit from bloom to bloom gathering nectar and pollen. Take your photo when the butterfly is feeding on a bloom. Try to fill the frame with the butterfly so your photo is more interesting to future viewers. Cottonwood leaves have a distinctive pattern. Look for a leaf or leaves that will make an interesting photo.

Get down on eye-level with the subject. It's a better angle and creates a more interesting photograph.

Summer tanager and other birds can be found at Cottonwood Campground in the summer.

Intermediate: A lot of birds make their home at Cottonwood Campground. You'll need at least a 300mm lens to take photos of the birds. A 75–300mm lens, 100–400mm, or 200–400mm zoom lens works well. Fixed lenses in the 300mm, 400mm, or 500mm range yield great results. Flashy red vermilion flycatchers are in the campground all year. Western kingbirds, with their lemon-yellow breasts and dark backs, nest in the trees during the spring and summer. Beautiful red summer tanagers are common during the same time. Watch for each of these birds as they "hawk" insects by flying out from a perch to snatch the prey in midair. The bird will usually return to the same perch to swallow the insect and settle down to spot their next victim.

Advanced: Cool-weather campers make great subjects for photos. At dusk or dawn, position yourself so a tent has a clear, unobstructed background. Illuminate the inside of the tent with a camp lantern or flashlight pointed up. From your position outside the tent, photograph the illuminated tent with the campground in the background. Have someone sit in the tent so his or her body shows as a silhouette in the photo. They have to sit completely still during the exposure. A person could be silhouetted outside the tent as well.

Season: Any season, but fall through spring are the most comfortable.

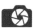 *Photography Tip*

The steady support of a good tripod is always needed for photos in low light. A tripod also helps to steady the camera when photographing birds. Get used to using a good tripod to reduce vibration and produce sharper, clearer photos.

Sublett House

The Sublett family brought modern irrigation and large-scale farming to the banks of the Rio Grande in the early part of the last century. Their small rock and adobe house is one-quarter mile off the road and worth a stop.

Simple: Frame your photograph so the ruins of the house flow away at an angle. Compose the image so a wall is very close to the lens.

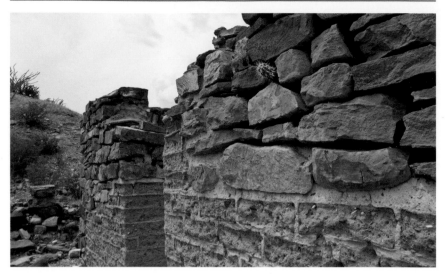

The adobe and stone walls of Sublett House are emphasized by using a wide angle lens positioned very close to the wall.

Intermediate: Look for an area of the house where the adobe walls are exposed. Use the light and shadows to accentuate the texture in the old adobe or cactus growing in the walls. Try to capture those details in your photo.

Advanced: The window or doorway of the old house makes a great frame to shoot through. Find an angle where one of your traveling companions, Cerro Castellan, or the surrounding desert is framed by a window or door. Add light to the window or doorway with a flash or reflector.

Season: Any season.

 Photography Tip

The sun can be intense in this area during the middle of the day. Morning or afternoon light is always good.

Santa Elena Canyon

Next to the Window View in the Basin, Santa Elena Canyon is my favorite thing to photograph in Big Bend. The canyon walls rise 1,500 feet above the desert floor. They are amazing.

A tiny cactus takes up residence in the stone wall at Sublett House.

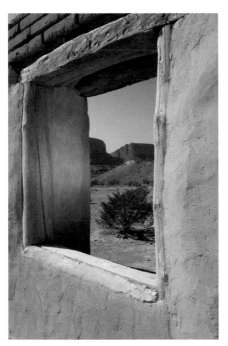

The window in an adobe structure makes an interesting frame for Santa Elena Canyon.

Simple: The Santa Elena Canyon Overlook along the highway is a nice spot for photographing the canyon. Use your wide-angle lens to frame the canyon so viewers can see how steep the walls are and how high they loom over the desert.

Intermediate: Walk out in the desert from the parking area of the Santa Elena Canyon Overlook. There is an impromptu trail that goes upriver along the bluff. Several really nice views can be found along this ridge that include the canyon, area lowlands, and the sky with a wide-angle lens in the 12mm, 14mm, 16mm, or 20mm range.

Tuff Canyon to Santa Elena Canyon

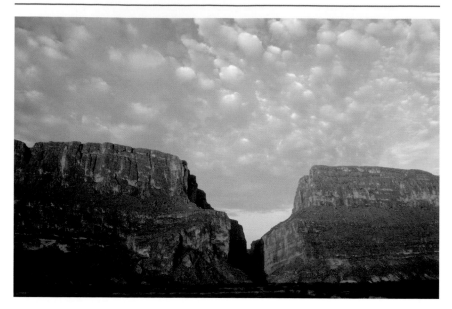

A wide-angle lens is used here to fit the sky and towering walls of Santa Elena Canyon in the same photograph.

Advanced: Santa Elena Canyon from the base of the canyon is magnificent. You'll need a tripod, a wide-angle lens, and a polarizing filter. Sunrise is the best time for even, subdued light on the canyon walls. Position yourself at the edge of the river with the tripod and camera low to the ground. Your photo should have the Rio Grande flowing into the bottom of the frame and some sky above the top of the canyon walls. Use a long exposure with f/22 to blur the motion of the water.

Season: Any time. Summer days are hot. Flash floods in the summer frequently close the road from Castolon to Santa Elena. Pay attention to the weather and posted road conditions. It's not the rain where you are that matters; it's the rain that fell last night upstream that will trap you.

 Photography Tip

Caution: I sank in the mud up to my thigh one time while I was trying to get a photo from the riverbank of the Rio Grande. The mud around Santa Elena can look stable. Test the area in front of you first before stepping. ■

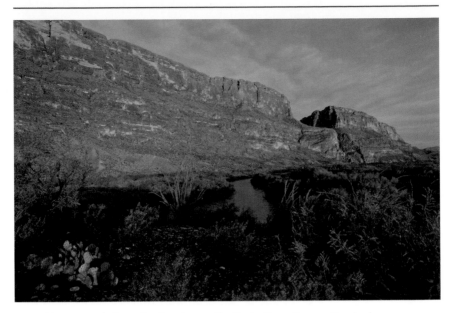

Santa Elena Canyon from the desert near the Santa Elena Canyon Overlook.

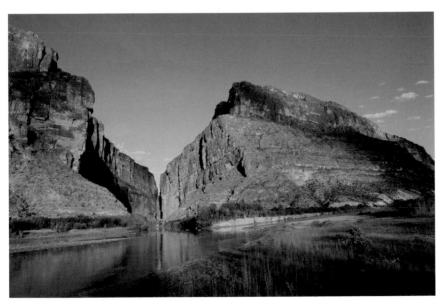

The view from the base of Santa Elena Canyon is magnificent. Use a wide-angle lens, tripod, and watch out for soft mud.

6 High Chisos Mountains

THE HIGH SECTIONS of the Chisos Mountains offer boundless photo opportunities. There's no easy way up the mountains, so it's one foot in front of the other for as long as your body can endure the stress. Remember to pack lots of water, wear good hiking boots, and take some food. A comfortable photographer takes better photos.

Juniper Flats

The hike up to Juniper Flats is steep enough to get the heart pumping and knees wobbling for many people. Use this as a rest stop if you're in great shape and heading up to the top of mountains. If you're less inclined to hiking, use this as a vantage point for some nice photos.

Simple: Stand along the edge of the trail at an open area that allows a view of Casa Grande. Look for a place where trees or shrubs can be a frame along the bottom and edges of your photo of Casa Grande.

Intermediate: Scout the area along the edge of the trail. Look for an overhanging branch that can frame the surrounding mountains. The tree branch should go along the top and right side of the photo with the mountains in the middle. Use your flash to illuminate the branch if it appears dark in your photograph.

Advanced: The grassy meadow that makes up Juniper Flats is a beautiful place. Skeletons of long-dead junipers stand majestically in the golden grasses with Toll Mountain and Casa Grande in the background. Capture an image of the grand landscape with a lens in the 14–20mm range.

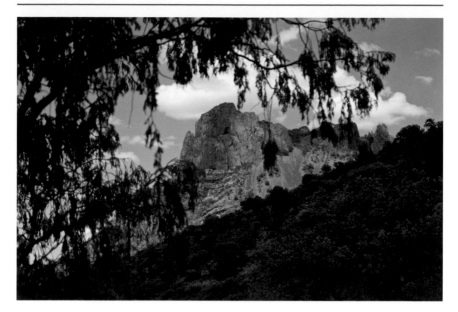

Tree limbs frame Casa Grande.

Season: Any season is good.

 Photography Tip

There are backcountry campsites in this area. Respect the privacy of campers and be a good neighbor.

Boulder Meadow

We don't think of grasslands in the desert but Boulder Meadow is a great example of a high mountain meadow. This lovely meadow is 1.5 miles from the Basin trailhead. Don't be fooled if you're from flat land. The hike is challenging but fun. Many people make it a half-day hike.

Simple: Notice the large agaves in the meadow. The grayish blue leaves of the agave next to green or gold grasses are pleasing to the eye because the colors are harmonious. Find a place where the agave can be the main subject of the photo with grasses in the foreground or background.

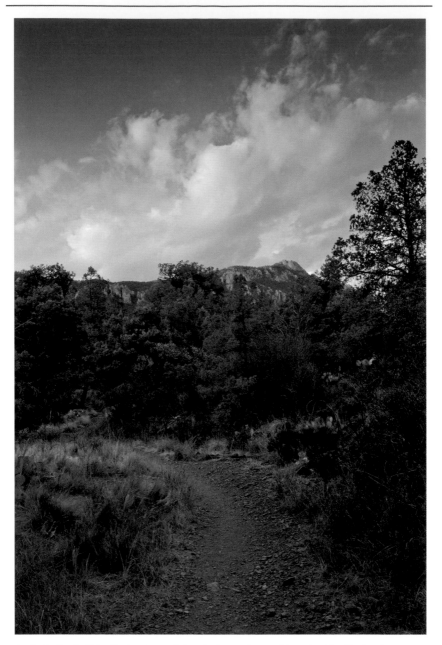

Include the trail in the bottom of the photograph to add context to the landscape.

Chapter 6

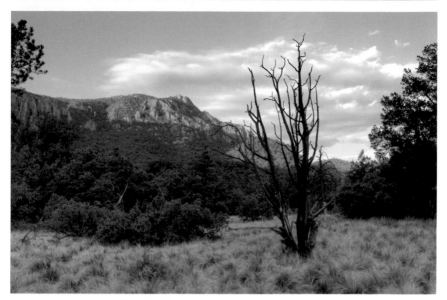
Walk the grasslands of Boulder Meadow to find an interesting point-of-view.

The patterns and subtle colors of grass and agave

Intermediate: Nassella (Stipa) grass or feather grass grows in large clumps throughout the meadow. Walk through the meadow and look for a feathery grass bloom that catches your eye. Position your camera so it's at eye level with the bloom, and the bloom is parallel to the back of the camera. Fill the frame with the bloom. Select an f/stop in the 4.5 to 6.8 range so there will be a nice soft background to your photo.

Advanced: This is a great place for a grand landscape. Walk the

A simple, small grasshead can be the subject of an interesting photograph.

meadow to find a clump of grass, piece of weathered wood, or boulder that will make an interesting foreground. With a lens in the 14mm to 20mm range attached to your camera, look through the viewfinder and compose the photo with foreground object, grasses, and mountains. Add a little flash to the foreground object to set it apart from the background. Remember to use an f/stop in the 16 to 32 range for maximum depth-of-field. Focus on the foreground object or slightly past it to ensure it's in focus.

Season: Any season but it can be cold in the winter. In the summer, this is a welcome respite from the heat in the Basin.

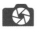 *Photography Tip*

Boulder Meadow can be a beautiful place when it is overcast, dreary, or foggy. You can always find a good photo where water condenses on grass heads or agave thorns.

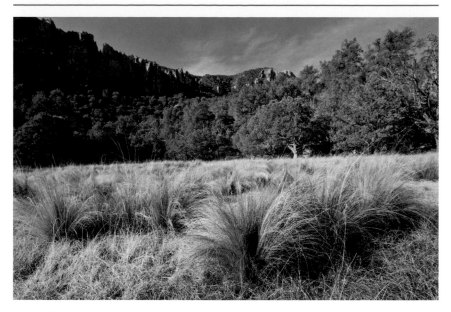

Use a wide-angle lens to capture the subtle beauty of Boulder Meadow and Juniper Flats.

Boot Springs

Boot Springs is a grueling 4.5-mile hike from the Basin trailhead. It's a killer hike up the Pinnacles Trail but so worth it because of the scenery. The Laguna Meadow trail is easier but not shorter.

Simple: The "boot" that gives this area its name can be seen in the distance near the intersection of Boot Canyon and Juniper Canyon. The upside down cowboy boot is really a volcanic spire. Take a photo of your hiking companions with the boot in the background. Be sure to focus on the people and not the boot.

Intermediate: Wildflowers abound along the trail to Boot Springs. The juxtaposition of a delicate plant growing in hard rocks is always an interesting photograph. Tube-shaped red blooms of the Mexican catch-fly or beardlip penstemon are a challenge to photograph but well worth the effort. Keep the bloom parallel with the back of the camera or flat to the film plane.

The Boot formation as seen from the trail to Boot Springs.

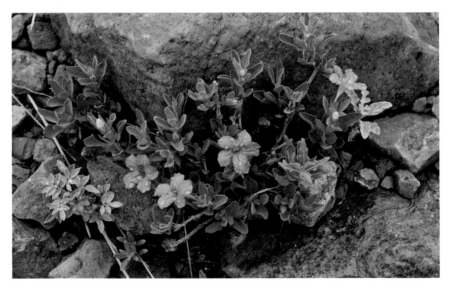

Slow down on your hike up to Boot Springs and take time to photograph the wildflowers.

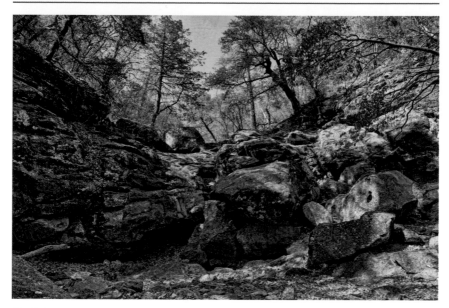
The light at Boot Springs can be contrasty during the day. To overcome the photographic challenge, try creating an HDR blend of several different images.

Advanced: Boot Springs usually has pools of water. Massive boulders, gnarled tree roots, and a mat of fallen leaves surround those pools. The setting calls for a wide-angle lens and tripod to do it justice. Pack both and work the areas around the pools. The contrasting light between areas in the shadows and areas in the sunlight will be a challenge. Hope for a little overcast light.

Season: Spring through fall.

 Photography Tip

Wildflowers bloom from spring to fall along the trail. The leaves on the oaks, maples, and cypress change color in late October to early November.

7 Photography at Night

I GOT A PHONE CALL from a lady. She wanted me to tell her where the "photographing a moving parade at night" button was on her camera. I told her I'd never heard of the "moving parade at night" button on a camera. She said a lady was standing next to her at a night parade and that lady fiddled with her camera, pushed some buttons, and got great photos of the parade. My caller wanted to know where this button was too.

There's no secret button on a camera that will allow photography at night. But photographing at night is not hard. There are two options.

Option One: Balance your light meter for the ambient light by using the aperture priority mode. (That's A or AV on most cameras.) Set the mode to aperture priority and select the f/stop you want for your photograph. The camera will balance the light meter with the shutter speed appropriate for the light. There will be a long shutter speed because it's dark, so fifteen, twenty, or thirty seconds is okay. These long shutter speeds are even highly desirable.

My starting point for night photography is aperture priority and an f/22. At twilight I might get 1/8th of a second shutter speed or 1/15th of a second. That's perfect. As the light fades, the shutter speed falls to full seconds and finally thirty seconds. That's 30" on most cameras.

The shutter speed number starts blinking when thirty seconds is not long enough to capture the light. When that happens, I adjust my f/stop to let in more light. I keep shooting until it's so dark that f/5.6 and thirty seconds won't work to balance the light meter. Then I increase my ISO or go to option two.

Option Two: When it's really dark, I use option two. Put the camera in the manual mode. Select the f/stop for the scene. Usually that's going to be f/5.6

to f/8 because we're not going for maximum depth-of-field at night. We're trying to get light from an otherwise dark situation so a big open aperture is good.

Turn off auto focus. Focus your lens with the aid of a flashlight or a silhouette in the distance. Turn off "auto focus assist" in your camera as this feature sends out a stream of light designed to help the camera focus. It's a pain and will ruin the photos of other photographers you might be shooting with.

There are times when it is too dark to balance the camera's light meter. That's when we move to bulb. Bulb allows the shutter to stay open longer than thirty seconds. In bulb mode, as long as you hold the shutter button down, the shutter will stay open.

How long should the shutter stay open in bulb? Start with a test shot at one-minute exposure. (Use your watch or simply slowly count to sixty.) Check the exposure on the back of the camera and with the histogram. Take another shot with a longer exposure if needed.

The longer the exposure, the more noise in your photo. Noise is graininess or even stray, odd colors in the finished photo. There is a setting on most digital SLR cameras called "internal noise reduction." That setting helps. Cold outside temperatures also help reduce the noise. Hence, the best long exposure photos are taken in colder environments or are done during the winter.

A note about high ISO—ISO 100 or 200 is the baseline setting on most cameras for fine grain and excellent color. The higher the ISO number the more grain in the photograph and the more color is compromised.

The latest cameras on the market are producing amazing photos with higher ISO settings. Using modern software specifically designed to reduce the grain can reduce graininess produced by using a high ISO. A new camera coupled with new software means it's possible to shoot with a higher ISO number. I'm still a fan of low ISO, though, for general photography.

A note about the moon—The light on the moon is reflected sunlight and it is very bright. Take a spot meter reading off the moon with a 500mm lens and you'll see that the exposure is in something like 1/250 at f/4.5. To get a crisp photo of the moon, be sure to use at least 1/60 of a second shutter speed to stop the movement of the earth as it rotates.

Painting with Light

Stationary objects can be "painted" with light during a long exposure at night. The resulting photo looks surreal. The light from a halogen flashlight or spotlight is blue. A traditional flashlight gives light that is golden in tone. Some flashlights or spotlights give a pure white light. A colored gel or filter can be added to a light to change the color.

Hunters use spotlights to illegally hunt wildlife at night in the park. As a result, park personnel are sensitive to anyone with a spotlight or powerful flashlight at night. If you're going to paint with light, be aware you might get a visit from park rangers. Also, Big Bend National Park is one of the darkest places in the country. A lot of visitors like to star gaze at night. Please do not disturb their evening with your spotlight.

Simple: Point the headlights of a car at your campsite, evening picnic, or desert scene. Put your camera on a tripod. For cameras that don't have an aperture priority mode or for simplicity, use the "low light" or "night mode." Use the aperture priority mode if your camera has it. Set the aperture at

Car headlights or a flashlight can illuminate a subject for an interesting nighttime photograph.

f/5.6 and use the self-timer to release the shutter. People in the scene should sit or stand very still during the exposure.

Intermediate: Find a stationary object in the park. My favorites are windmills. The windmill at Dugout Wells is a nice subject to paint with light. It's not too big and easily accessible. Put your camera on a sturdy tripod, shutter priority, and dial in thirty seconds for the shutter speed. That's 30" and not 30 or 1/30. You want thirty seconds so there's enough time to bathe the entire windmill in light from your flashlight or spotlight.

With the camera on a sturdy tripod, trip the shutter using a shutter release or the camera's built-in timer. While the shutter is open, paint the windmill with light from your flashlight. Be sure to cover the entire windmill. Check the resulting photo and repaint until you're satisfied with the final photo.

Advanced: Find a stand of yucca, a windmill, a rock feature, or old building in the park. Use two different-colored flashlights or spotlights to paint the object. Paint the front of the object with a golden light and the side of the object with a bluish light. The two contrasting colors will give the object a more natural three-dimensional look. Let the shutter stay open for four or five minutes to get star trails.

Season: Any season works well.

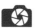 *Photography Tip*

Slow and steady movement with the flashlight gives nice even lighting. Paint with your light as you would paint with a brush. Keep the light smooth and even.

Tunnel at Rio Grande Village

The tunnel near the Rio Grande Overlook makes an interesting subject for night photography.

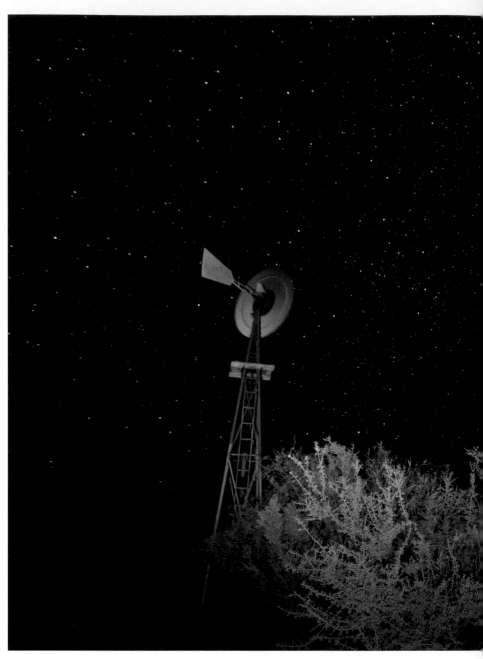

Different types of flashlights produced different colors of light on the foreground of this image of the windmill and Milky Way.

Simple photograph of a car driving through the tunnel near Rio Grande Village.

Simple: An hour after sunset, place your camera on a tripod on the shoulder of the road at the turn-off to the Rio Grande Overlook. Point your camera so there is some road in the foreground and the tunnel in the background. Set your camera on aperture priority an f/22. Click the shutter as cars drive through the tunnel. Cars coming toward you will leave white streaks of light and cars driving away from you will leave red streaks of light.

Intermediate: Follow the instructions above but place your camera low to the ground. Use a super-wide-angle lens in the 10mm or 12mm range to accentuate the road in the bottom of the photo.

Advanced: Take several photos without moving the tripod of cars driving through the tunnel. Blend the images together using the steps below in the section "Star Trails." The finished photo will look like several cars drove through the tunnel while you were taking the photograph.

Season: Any season.

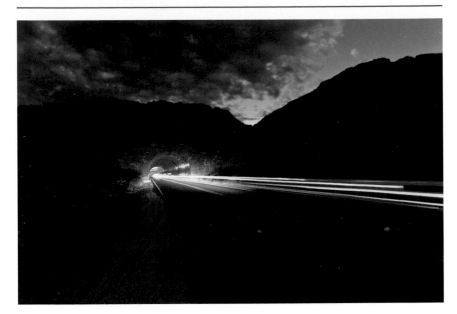

The concept is enhanced by a lower camera angle and wide-angle lens
(compare with below).

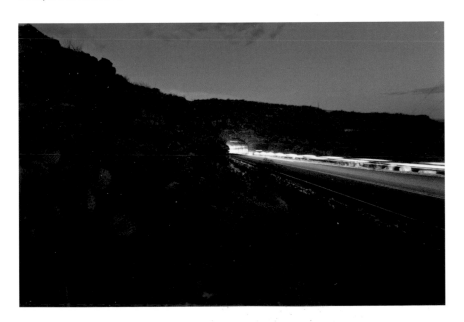

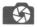

There isn't a lot of traffic in Big Bend National Park. Ask your traveling companions to drive in and out of the tunnel so you can get lights in your photograph.

Full Moonrise over the Desert

The full moon cresting the horizon in Big Bend is an amazing site. Check your calendar to see if you get a full moon during your visit.

Simple: On the night of the full moon, if you're standing in the Basin, the full moon crests over Chisos Mountains an hour to two hours after sunset. It is dramatic and looks like a spotlight coming over the mountains. Use a lens in the 200mm or 300mm range to silhouette the moon against the trees on the mountain ridges. Be sure the camera is on a sturdy tripod.

Intermediate: The flat desert between Dugout Wells and Tornillo Creek is a great place to watch the moon rise.

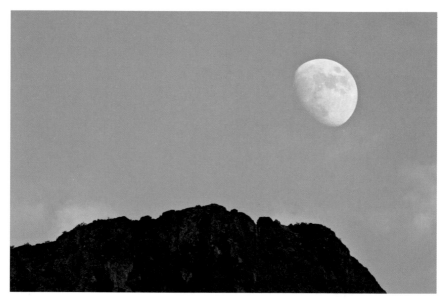

Moon and Casa Grande.

Advanced: On the night before the full moon, the moon comes into view low on the horizon in a twilight sky. The deep purple or blue sky compliments the nearly full golden moon. Consult a moon phase chart to get the compass direction for the moonrise. Drive the park or hike the trails to find the perfect vantage point where the moon will enhance your photograph. My favorite areas are Tuft Canyon, Grapevine Hills, and the hill near the wetland nature trail at Rio Grande Village.

Season: There's a full moon every month so lots of opportunities.

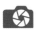 *Photography Tip*

Moonset can be as dramatic as moonrise. Consult moon phase charts to catch the moon in the morning sky.

Star Trails

Back before digital photography, we could photograph the trails of light left by the stars as the earth rotated through the night sky. We set the shutter to bulb and aperture to f/4.5 or f/5.6. Then we locked down the shutter with

The area around Dugout Wells and Tornillo Creek is a great place to watch the moonrise.

a shutter release and took a four- or five-hour exposure. A week later after having the film developed, we got to see if our photo was a success or failure. More often than not, my images of star trails in Big Bend were a failure because I bumped the camera, a security light came on in the scene, or a vehicle drove though the photo.

Today in the digital era, photos of star trails are much easier. We can't leave the shutter open for hours like we could on a film camera. But we can take multiple photos, stack them together in layers and, using software, blend the layers. The finished photo shows the light from the stars trailing through the sky.

Simple: Put your camera on a sturdy tripod. Install a shutter release on the camera. Set the shutter speed to bulb. Set the aperture to f/4.5. ISO can be set in the 400 range. Focus on a silhouetted object or use a flashlight to help focus on something in the distance. Click the shutter button and hold it down with the shutter release for one minute. Magnify the photo and you should see trails of light created by the stars.

It's pretty simple to take a photograph of the stars in Big Bend.

Intermediate: Compose a scene with lots of sky and mountains at the bottom of the frame. Follow the instruction above but use a programmable shutter release called an intervalometer. Program the shutter release to take a four-minute-long exposure with a one-second break between images. Set your camera to take large jpg photographs since you're going to blend the images. Take photos over a two- or three-hour-long period. The last photo in the series should be totally black. (I put the lens cap on for this last photo.) Blend the images using the instructions below.

Advanced: Point your camera at the North Star so the star is slightly off center. Use the same instructions as above but take photos over a longer period of time. Be sure you start with a fully charged battery and memory card big enough to handle all the images. Trip the shutter with the shutter release to begin the series of images. Paint the foreground with light during the first photo. Follow the instructions for blending the images below.

Season: Any season, but winter has the clearest skies.

Star trails are the light from the stars as the earth rotates. Long star trails come from blending images taken over several hours into one photo.

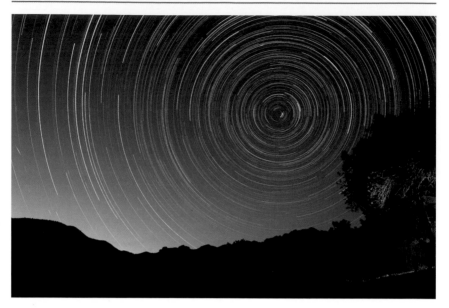

This is a layer blend of many images taken over several hours. Each image was a 4 minute exposure. The pivet point is the North Star.

 Photography Tip

Follow these instructions precisely to create a layer blend in Photoshop.

1. Download the images into a folder.

2. Open Photoshop Bridge and then open the folder.

3. Highlight all the images.

4. Click Tools>Photoshop>Load Files into Photoshop Layers. Photoshop should open with the images in a layer pallet.

5. Move the "painted" image to the top of the stack if it is not already there.

6. Move the dark image so it is under the painted image.

7. Click the first image in the stack and change the blend mode to Lighten.

8. Right click that layer and click Copy Layer Style.

9. Select all the other layers except the dark photo and the bottom photo.

10. Right click the layer and select Paste Layer Style.

11. Click the dark layer and change the blend mode to Difference. The last layer should still be in the Normal mode.

12. Flatten the image to see your photo of the star trails. Make any necessary exposure, contrast, or other corrections.

Milky Way

You'll need a dark sky with no moon to get a nice photo of the Milky Way. When we look at the Milky Way and marvel at all the stars we're really looking at our galaxy from the side as if we'd sliced a pancake in half.

Regardless of the type of camera you use to photograph the Milky Way, you'll need a 1/60th of a second shutter speed and a small f/stop. Ideally, you'd want to use f/2.8 but f/3.5 would work. At night that won't balance the light meter, so you'll have to raise the ISO number to get a good exposure where the stars show in the sky. Check the histogram on the back of the camera after taking the photo. Raise or lower the ISO to get the correct exposure.

Simple: Put your camera on a tripod with a wide-angle lens. Point the camera at the sky with the Milky Way in the scene. Set the camera as above. Trip the shutter with a shutter release or the camera's built in timer.

Intermediate: Position something in front of the Milky Way, like a yucca or blooming agave stalk, so there's a silhouette of the object in your photo.

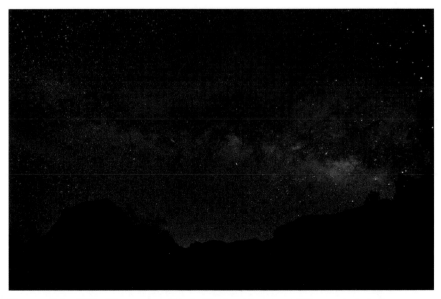

Photos of the Milky Way are possible in Big Bend because of the area's dark sky.

Interesting elements like an agave enhance an image of the Milky Way.

Advanced: Place an object or rock formation in your composition. Paint the object with a flashlight or the headlight of your car while the shutter is open. You might have to repeat the photo many times to get the light on the object just right. This works best with a cooperative assistant to man the flashlights.

Season: Summer is best but with good viewing spring through fall.

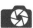 *Photography Tip*

There's a setting on most cameras called "long exposure noise reduction." This setting gets rid of noise in a photograph by eliminating "noisy" pixels. The camera needs time to process this operation. After the initial exposure, a second exposure of identical length is made with the shutter closed. The noise from the second "dark frame" exposure is subtracted from the first image in camera. A thirty-second exposure needs thirty more seconds to eliminate the noise. A sixty-second exposure needs sixty seconds.

Flashlights were used to light the foreground in front of the Milky Way.

A five-minute exposure needs an additional five minutes. Needless to say, I use this function when taking long exposures but not really long exposures. Be sure to turn this feature off when you are shooting multiple exposures for your star trails or you will have gaps in the trails while the camera is shooting the dark frame exposures. For your star trail series, you will take care of making a dark frame when you take the shot with the lens cap on, and then you will subtract it later using software. ■

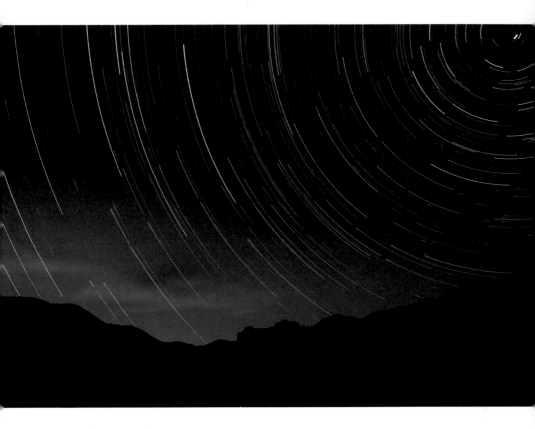

Glossary

aperture: Opening in the lens formed by blades of metal. The size of the opening controls how much light comes through the lens. That opening also factors into depth-of-field, or area in focus, in the final photograph.

ball head: A device that holds the camera and lens atop a tripod. A ball head has small knobs rather than handles like a pan-tilt tripod head. A metal ball sits in a holder and rotates as the photographer moves the camera into position. Once the camera is in the right position, the knobs are tightened to lock it in place.

bokeh: This word has its origin in the Japanese word *boke* or blur. It refers to the out-of-focus areas in a photograph as a result of the opening in the aperture. A wide aperture causes a shallow depth-of-field or area in

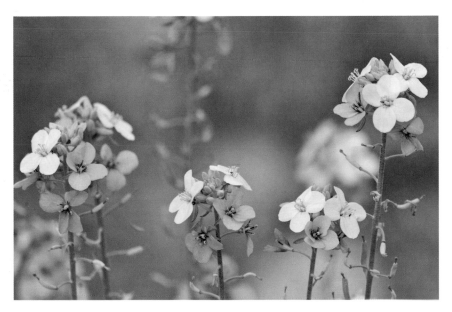

Good bokeh comes from the structure of the lens. The blurred area in the background of a photo should look natural versus having odd pentagon or octagon shapes.

focus. A shallow depth-of-field results in blurring behind and/or in front of the subject. Both spellings are acceptable.

close-up diopter: A specialized filter that screws on the front of a lens. The diopter acts as a magnifying glass, which allows for close focus. Many photographers use an extension tube and close-up diopter for high-magnification photography.

depth-of-field: The area in focus in a photograph. The area in focus is parallel to the sensor in the back of the camera. Depth-of-field is narrow at a small f/stop, such as f/3.5 or f/4. Depth-of-field is wider at a large f/stop, such as f/16 or f/22.

evaluative light meter: A light meter that reads the light in various locations through the picture and then analyzes the light to get the best exposure.

extension tube: a piece of camera equipment that looks like a hollow tube. The extension tube fits between the lens and camera body. Optically, this allows the lens to focus closer. Many people use an extension tube and a regular lens instead of a more expensive macro lens.

fixed f/stop zoom lens: This is a lens that is designed to have a set f/stop throughout the zoom range. For example, a 70–200mm f/4 lens offers access to f/4 no matter where the zoom is set. This design produces a lens that is usually heavier and more expensive than other lenses. The trade-off is the ability to use the lens with a wide aperture no matter where it is zoomed. See "variable f/stop zoom lens."

flat to the film plane: Depth-of-field, or the area that is in focus in a photograph, is parallel to the film plane. Most of us don't use a film camera anymore, but the sensor in our digital cameras is in the same space that once held film. Depth-of-field is parallel to the back of the camera or flat to the film plane. Depth-of-field, or the area in focus, is roughly one-third in front of the focus point and two-thirds behind the focus point.

f/stop: Numerical notation for the opening in the aperture of the lens.

highlight indicator: This is a great tool and should be activated on every camera. The indicator on the back of a camera blinks in areas where the brightest areas of the photo (the highlights) have been over-exposed. That means there is no information in the blinking area of the photograph. Put another way, there will be no ink on the paper in the blinking area when the photo is printed. When this happens, the area without

information is said to be "blown out." Our goal is a photo with no blown highlights.

histogram: The histogram is a graph of the 256 possible tones in a photograph. A good histogram fills the entire graph from left to right. The left corner of the graph is pure black pixels with no detail. The right corner is pure white with no details. The first section of the histogram on the right is the most important section. That shows that the white tones were captured. White tones are difficult to artificially recreate later on in processing software. Dark tones are easier to recreate later in software.

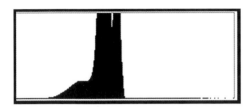

A histogram shows if all 256 tones in the photograph were captured. A histogram that doesn't touch the right side is missing some light to white tones. The light meter should be moved to over-expose the image. The histogram should not spike up the right side.

hyperfocal distance: The area in focus in a photograph is based on three variables. Those variables are focus point, f/stop, and lens. It was once easy to visually determine the hyperfocal distance: put a nifty scale on the barrel of each lens. Modern auto-focus lenses rarely have this scale. Hyperfocal distance can be determined by using a chart or by using the depth-of-field preview button on the camera. Photographers use the preview button more often.

jpg file format: Pronounced jay-peg. One of the file format options available in digital photography. Jpg photographs are processed by the camera, finished inside the camera, and then compressed. Jpg photos are usually considered ready for printing or uploading to the web. See "raw file format" for another file format.

lens flare: A bright spot or a trail of light, usually at a diagonal, through a photograph. Lens flare is caused by a stray burst of light from the sun or other strong source bouncing off the glass inside the lens. A UV filter on the front of the lens will introduce another surface for light to bounce off of and can make lens flare worse, especially at night. Lens flare can be interesting in a photograph but usually is considered a nuisance.

lens hood: A hard device that fits on the front end of your lens. It is designed to block stray light that can cause lens flare, but it will also serve as a shock absorber in the event you bang the lens against a rock or drop the camera. If you have one, use it all the time.

light meter: A piece of equipment inside the camera body that reads the light coming into the lens. The light meter "communicates" to the photographer through a scale that is visible in the bottom of the viewfinder when the camera is turned on. Some cameras have a numerical scale (−3, −2, −1, etc.) instead of a scale. The light meter scale is also visible on the back LCD panel in most cameras.

matrix light meter: See "evaluative light meter."

monopod: A long pole sold as an aid to keep a camera steady. For nature photography, a monopod is usually worthless and impractical. Save your money and buy a tripod.

noise: Stray colored pixels that come from using a high ISO setting. These stray pixels can be fixed in the camera with noise reduction or in the computer with several different types of software.

pan-tilt head: A tripod head that is commonly used when shooting video. Usually has one to three handles off the head. One handle controls panning and one handle controls tilting. See "ball head."

polarizing filter: Reduces the glare off the surfaces of rocks, grass, leaves, and water. Reduces the glare from the sky and gives a bluer sky and whiter clouds.

prime lens: A lens that is fixed at one focal length, for example, 100mm or 24mm. Prime lenses do not zoom. See "zoom lens."

raw file format: One of the file format options available in digital photography. Raw files are the largest file size available in a digital camera. The files are minimally processed in the camera and minimally compressed. They take up more space on a storage card or computer. Raw files have to be converted to jpg or tiff format before printing. Raw files are too large to upload to a basic website or social networking site, so they have to be converted to a jpg. Canon uses the file extension .crw, and Nikon uses the file extension .nef for their raw files.

reflector: a piece of photography equipment used to reflect light onto a subject. Most reflectors are round disks with a shiny silver surface on one side and a shiny gold surface on the other side. The silver surface reflects

a cool, white light. The gold surface reflects a warm, golden light. Many reflectors twist to fold down to a compact size that fits in a zippered storage case.

Silhouette: Dark subject in the foreground against a light subject in the background.

split neutral density filter: A filter that blocks the light in one part of the photograph, usually the sky. Round split neutral density filters that are dark on one side and light on the other are useless. Use a rectangular filter that can be moved around to put it in the right position.

telephoto lens: A lens in the 100mm or higher range. Telephoto lenses allow you to photograph things at a distance. Objects in the photo appear closer. See "wide-angle lens."

tripod: A serious photography tool designed to keep the camera steady and greatly reduce vibrations.

UV filter: Usually a cheap filter that does more harm than good. Good UV filters cost up to $50 or $100 and cut some haze out of the air. See "lens flare."

variable f/stop zoom lens: This is a lens that is designed to have a different minimum f/stop at different areas of the zoom range. For example, an 18–135mm lens might have a minimum f/stop of 3.5 when it is set to 18mm but a minimum f/stop of 5.6 at 135mm. This design allows lenses to be lighter and less expensive.

wide-angle lens: A lens in the 10mm to 24mm range. Looking forward, your eye sees a field of view roughly equal to the view through a 50mm lens. A lens in the 18mm range captures a field of view equal to the area you'd see if you moved your eyes from side-to-side and up-and-down. See "telephoto lens."

zoom lens: A lens that is designed to move through a variety of focal lengths. The most common zoom lenses come in the 18–135mm or 70–300mm range. The 18–135mm is called a wide-angle zoom because it gives a wide field-of-view. The 70–300mm is called a telephoto zoom and is used to make far-off objects appear closer. See "prime lens."

Index